KEN HOM'S QUICK & EASY

CHINESE COOKING

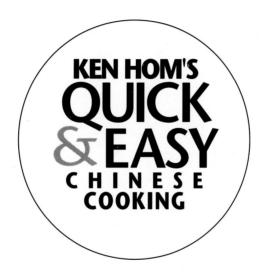

Photography by Paul Berg

Chronicle Books · San Francisco

Copyright © 1990 by Chronicle Publishing Company. Text copyright © 1989 by Taurom Inc.

All rights reserved. No part of this book may be reproduced in any form without written permission from the publisher.

Printed in Japan

Library of Congress Cataloging-in-Publication Data Hom, Ken.

[Quick and easy Chinese cooking] Ken Hom's quick and easy Chinese cooking / photography by Paul Berg.

p. cm.
ISBN 0-87701-836-7
ISBN 0-87701-770-0 (pbk.)
I. Cookery, Chinese. 2. Quick and easy cookery. I. Title. II. Title: Quick and easy Chinese cooking.
TX724.5.C5H6657 1990
641.5951-dc20 90-34873

90-34873 CIP

Editing: Mimi Luebbermann and Carolyn Miller Book and cover design: Ingalls + Associates

Designer: Tracy Dean

Composition: Walker Graphics Food Stylist: Sandra Cook

Assistant Food Stylist: Helen Casartelli Props and Set Design: Hilda Shum

Distributed in Canada by Raincoast Books, 112 East Third Avenue, Vancouver, B.C. V5T 1C8

10987654321

Chronicle Books 275 Fifth Street San Francisco, CA 94103 Special Thanks to:
Sophie Wong, Oakland
Ina Chun & John Mero of OHANA RANCH, Sebastopol
Annieglass Studio, Santa Cruz
Guy and Leanne Corrie of Union Street Glass, Oakland
Tail of the Yak, Berkeley
Smyers Glass, Benicia
Anne Stewart, Berkeley
Betty & Babe Rose, Oakland
Kathleen Rumberger Ceramics, Kensington
Richard Padfield, Oakland
Michael & Mieko Kahn, Albany
Wood Innovation, Napa

Contents

Introduction 8
Basic Chinese Pantry
The recipes
Appetizers and First Courses
Soups
Fish and Shellfish42
Poultry65
<i>Meats</i>
Vegetables
Rice and Noodles12
Desserts
Quick & Easy Menus14
Index140

Introduction

All of the recipes and menus in this book are designed for simplicity and rapidity of preparation. We need to make it clear that "quick and easy" entails no sacrifice of quality. It does not imply machine-made fast food. It means only that the more elaborate and time-consuming recipes and menus of Chinese cooking have been omitted or refashioned in order to expedite the preparation of authentic and delectable meals. The essence remains the same; only the element of time has been changed.

Cooking quickly and easily comes naturally to those who spend a good deal of time in the kitchen. Of course, it is to be expected that elaborate multicourse dinners take much more time and effort. But not every meal is a major social or family event; no cook *always* has enough time, and sometimes, perhaps more often than not, a quick, easy, delectable, authentic meal is just the right thing. The preparation of such meals is what this book is about.

I have been developing these quick and easy recipes and techniques over the years, and more so of late, as my professional responsibilities have encroached upon my available kitchen time. Freshness of central ingredients remains my primary concern. I have, however, employed alternative techniques and allowed for substitution of secondary ingredients.

This has not been as difficult as it might seem. Except for a few sauces and seasonings, authentic Chinese cooking is not limited to certain ingredients, the way, for example, Japanese cooking is. Thus tomatoes, corn, potatoes, sweet potatoes, asparagus, and a host of "alien" foods have been readily accepted into Chinese cooking. Remember, too, that not all processed foods are to be scorned: canned tomatoes are an excellent substitute for fresh, and

frozen vegetables are sometimes superior to (and cheaper than) fresh but out-of-season varieties. And thus we may use Western ingredients in Chinese dishes if necessary or desirable.

Refinements of techniques matter, very much, but they too may be modified or adjusted as the food or time available permits. Pressure cookers, electric mixers, slow cookers, food processors, and even microwave ovens have been accepted into Chinese kitchens. All time and energy savers, all perfectly acceptable to use—after all, even the wok was once an innovation.

There is a reason why Chinese cooking is popular the world over: technique and a few essential seasonings can make anyone's native foods "Chinese." These same virtues make for excellent quick and easy food. What matters, once your pantry is stocked, is organization, the right recipes, and experience. Use this book as a point of departure. When you shop, do it when you can take your time: savor the experience of building your pantry. Note that some of the recipes have a longer list of ingredients; this is essential to capture the flavors of authentic good cooking. Even quick and easy cooking requires your attention—but there are few things in this world more worthy of your time and concern or more rewarding than good food.

Introduction 9

Basic Chinese Pantry

Quick and easy cooking is, well, quick and easy, once you have at hand a basic Chinese pantry. These items, no longer exotic, are readily available in supermarkets and specialty markets. And there need be very little waste involved in stocking up your cupboard, as almost every one of these basic ingredients will keep nicely for a long time. You will have to shop only for fresh ingredients—those given in the Shopping List at the beginning of each recipe. It is assumed that, having read this section, you will already have the staples on hand.

Remember too that if your pantry lacks an ingredient, something else can usually substitute for it. Soy sauce is probably the only seasoning whose flavor cannot be replaced. Everything else is a matter of taste, *your* taste. You are in command!

BEAN CURD

Bean curd is also known by its Chinese name, *dou foo (dofu)*, or by its Japanese name, *tofu*. It has played an important part in Chinese cooking for over 1,000 years because it is highly nutritious, rich in protein, and goes well with other foods. Bean curd has a distinctive texture but a bland taste. It is made from yellow soybeans that are soaked, ground, mixed with water, and then cooked briefly before being solidified. It is usually sold in two forms: as firm cakes or in a soft custardlike form. It is perfect for quick and easy cooking because it is so versatile, needs little cooking, and can be easily combined with other foods. It is also quite inexpensive. The soft bean curd (sometimes called *silken tofu*) is used for soups and other dishes, while the firm type is used for stir-frying, braising, and deep-frying. Bean curd "cakes," white in color, are sold in many supermarkets or Asian markets. They are packed in water in plastic containers and may be kept in this state in the refrigerator for up to 5 days, provided the water is changed daily. To use bean curd, cut the amount required into cubes or shreds using a sharp knife. Do

this with care, as it is delicate. It also needs to be cooked gently, as too much stirring can cause it to disintegrate. This does not, however, affect its nutritional value.

BLACK BEANS, SALTED

These small black soybeans, also known as *fermented black beans*, are preserved by being fermented with salt and spices. They have a distinctive, slightly salty taste and a pleasantly rich smell, and are used as a seasoning, often in conjunction with garlic or fresh ginger. Their appetite-stimulating aroma can quickly transform an ordinary fast meal into something special. Black beans can be combined with a number of foods, giving them a deep, rich flavor. They are inexpensive and increasingly easier to obtain; I see them often in supermarkets. Although you can find them in cans as Black Beans in Salted Sauce, you may also see them packed in plastic bags, and these are preferable. The beans are usually used whole or coarsely chopped. Although some recipes say to rinse them before use, for fast cooking I never bother with this. The beans will keep indefinitely if stored in the refrigerator or in a cool place.

BLACK RICE VINEGAR, see Vinegars

BOK CHOY (Brassica chinensis)

Bok choy, also known as *Chinese white cabbage*, has been grown in China for centuries. Although there are many varieties, the most common and best known has a long, smooth, milky-white stem and large, crinkly, dark green leaves. The size of the plant indicates how tender it is. The smaller the better, especially in the summer, when the hot weather toughens the stalks. It has a light, fresh, slightly mustardy taste and requires little cooking. Bok choy cooks quickly in soup and takes minutes to stir-fry—perfect for fast cooking. It is now widely available in supermarkets. Look for firm crisp stalks and unblemished leaves. Store it in the bottom of your refrigerator.

CAYENNE

Cayenne pepper is made from dried red chilies and is also known as *chili* powder. It is pungent and aromatic, ranging from hot to very hot; it is thus widely used in many spicy dishes. You can buy it in supermarkets.

CHILI BEAN PASTE, see Thick Sauces and Pastes

CHILIES (Capsicum frutescens)

Fresh hot chilies—the seed pods of the capsicum plant—are used extensively in Chinese cooking. Although a relatively new ingredient, having been introduced from South America about 100 years ago, the chili has spread rapidly throughout Asia. Chilies are more and more available in supermarkets and specialty produce stores. Although seldom used in traditional Cantonese cooking, they are ideal for flavoring food. They provide color and form when used as a garnish, and are also added, chopped, to many dishes and sauces that require fast cooking. They are available fresh, dried, or ground.

Fresh Chilies

The fresh chilies found in China are long and usually pointed. Both red and green chilies are available. Their taste is mildly spicy and pungent. Smaller varieties can be found, but the larger, longer ones are the ones most widely available. Look for fresh chilies that are bright in color, with no brown patches or black spots. Use red chilies if possible; they are generally milder than green ones, because chilies sweeten as they ripen.

To prepare fresh chilies, first rinse them in cold water. Then, using a small sharp knife, slit them lengthways. Cut out the core and remove and discard the seeds. Rinse the chilies well under cold running water and prepare them according to the instructions in the recipe. Wash your hands, knife, and chopping board before preparing other foods, and be careful not to touch your eyes until you have washed your hands thoroughly with soap and water.

Dried Chilies

Although dried red chilies are associated with Szechwan-inspired dishes, they add dimension to many other types of cuisine. Some are small, thin, and about ½ inch long. They are used whole to season oil for stir-fried dishes, or are split and used in sauces or in braised dishes. Dried chilies can be bought in most supermarkets, and they will keep indefinitely in a tightly covered jar in a cool place.

CILANTRO (Coriandrum sativum)

Cilantro, also known as *Chinese parsley* or *fresh coriander*, is one of the relatively few herbs used in Chinese cooking. It is popular throughout southern China. It looks like flat parsley, but its pungent, musky, citruslike flavor gives it a distinctive character that is unmistakable. Its feathery leaves are often used as a garnish, or the herb is chopped and then mixed into sauces and stuffings. You can obtain it in many supermarkets now. When buying cilantro, look for deep green, fresh-looking leaves. Yellow and limp leaves indicate age and should be avoided.

To store cilantro, wash it in cold water, drain it thoroughly or spin it dry in a salad spinner, and put it in a clean plastic bag with a couple of sheets of moist paper towels. I learned this technique from my cooking associate, Gordon Wing, and it works wonderfully. Store it in the vegetable compartment of your refrigerator; it will keep for several days.

COCONUT MILK

Widely used throughout Asia, coconut milk is more important than cow's milk in the cooking of the region. It has some of the properties of cow's milk: the cream rises to the top when it is left to stand; it must be stirred as it comes to a boil; and the fat is chemically closer to butterfat than to vegetable fat. Coconut milk is not the liquid inside the coconut but the liquid wrung from the grated and soaked flesh. It can be bought frozen or in cans. Both kinds are of good quality and perfect for quick and easy cooking. For the purposes of this book, I recommend canned unsweetened coconut milk, which I have found is quite acceptable and involves much less work than preparing your own. Look for the brands from Thailand or Malaysia; you can find these at specialty markets. They usually are in 14-ounce or 15-ounce cans. Be sure to shake the can well before opening. Place any leftover coconut milk in a covered glass jar and store in the refrigerator, where it will keep for a week.

CORNSTARCH

In China and Asia many different flours and types of starch, such as water chestnut powder, taro starch, and arrowroot, are used to bind and thicken sauces and to make batter. Formerly, traditional cooks used a bean flour because it thickened faster and held longer. Cornstarch can help make quick, light sauces that barely coat the food so that the food is never swimming in thick sauce. Added to a marinade, cornstarch helps to coat the food properly and gives the finished dish a velvety texture. It also protects food during deep-frying by helping to seal in the juices and produces a crisper coating than flour. It is used as a binder for stuffings, too. When using cornstarch in a sauce, first blend it with cold water until it forms a smooth paste and add it to the sauce at the last moment. It will look milky at first, but as the sauce cooks and thickens, it will turn clear and shiny.

CURRY POWDER OR PASTE

Curry flavors have been widely adopted by Chinese cooks. However, the Chinese like to use them more in the French style, achieving the fragrant aroma of curry but avoiding the overwhelming pungent spiciness that the Indians and Thais prefer. The most frequently used curry flavoring takes the form of a prepared paste in which spices are mixed with oil and chilies. It has a better curry taste than the powdered variety. Be sure to get the Indian curry powder or paste, often labeled Madras, which is generally the best. You can find these at some supermarkets and at many specialty markets. If stored in the refrigerator after opening, curry paste keeps indefinitely.

FIVE-SPICE POWDER

Five-spice powder, also known as *five-flavored powder* and *five-fragrance spice powder*, is available in many supermarkets (in the spice section) and in specialty markets. In Hong Kong, Chinese chefs use this traditional spice in innovative ways, such as for marinating the inside of a Peking duck. It is a brownish powder consisting of a mixture of star anise, Szechwan peppercorns, fennel, cloves, and cinnamon. A good blend is pungent, fragrant, spicy, and slightly sweet at the same time. The exotic fragrance it gives to a dish makes the search for a good mixture well worth the effort. Stored in a well-sealed jar it keeps indefinitely.

GARLIC (Allium sativum)

The pungent flavor of garlic is part of the fabric of Chinese cuisine. It would be inconceivable to cook without its distinctive, highly aromatic smell and unique taste. It is used in numerous ways—whole, finely chopped, crushed, and pickled—and in Hong Kong I have even found it smoked. Garlic is used to flavor oils as well as spicy sauces, and is often paired with other equally pungent ingredients such as green onions, salted black beans, curry, shrimp paste, or fresh ginger. For quick and easy preparation, give the garlic clove a sharp blow with the flat side of your cleaver or knife, and the peel should come off easily. Then put the required amount through a garlic press, rather than chopping it in the traditional way—this saves time and works just as well.

Select fresh garlic that is firm and heavy, with cloves preferably pinkish in color. It should be stored in a cool, dry place, but not in the refrigerator where it can easily become mildewed or begin to sprout.

GINGER (Zingiber officinale)

Fresh ginger root (it is actually a rhizome, not a root) is as ancient, traditional, and essential in Cantonese cooking as the wok. It is said that ginger from Canton is the most aromatic. Like garlic, it is an indispensable ingredient in Chinese cooking. Its pungent, spicy, and fresh taste adds a subtle but distinctive flavor to soups, meats, fish, sauces, and vegetables. Ripe ginger is goldenbeige in color, with a thin, dry skin that is usually peeled before the ginger is used. It varies in size from small pieces to large knobby "hands." Older, shriveled ginger is used for medicinal broths. Look for "roots" that are firm, solid, and unmarked, with no signs of shriveling. If stored in plastic wrap or bags, ginger will keep in the refrigerator for up to 2 weeks. Peeled ginger stored in a glass jar and covered in rice wine or dry sherry will last for several months. This has the added benefit of producing a flavored wine that can be used in cooking.

Young ginger sometimes makes its appearance in specialty markets. It is hard to find but well worth the search. Knobby in shape and pink in color, looking rather unformed, it is the newest spring growth of the plant. Young ginger is usually stir-fried as part of a dish; in China it is commonly pickled. Because it is young and tender, it does not need peeling and can be eaten as a vegetable. A popular way to eat pickled young ginger is with preserved thousand-year-old duck eggs as a snack; it is also often served as an hors d'oeuvre.

HOISIN SAUCE, see Thick Sauces and Pastes

MUSHROOMS, Chinese Dried

There are many grades of these wonderful mushrooms, said to have been produced for more than 1,000 years in southern China. Black or brown in color, they add a special flavor and aroma to Chinese dishes. The best are very large, with a light color and a highly cracked surface; they are usually the most expensive. As you may imagine, mushrooms are very popular in Chinese cooking. Dried-food shops in China carry all grades heaped in mounds, with the more expensive grades elaborately boxed. Outside China, they can bought from specialty markets in boxes or plastic bags. Chinese dried mushrooms are expensive, but a little goes a long way. Keep them stored in an airtight jar in a cool dry place. Fresh mushrooms (popularly known as *shiitake*, a Japanese word) are not an adequate substitute; the Chinese never use them fresh, preferring their distinct, robust, smoky flavor and yielding texture when dried. They are used chopped and combined with meats, fish, and shellfish. They are well worth the relatively short time it takes to prepare them, as they add a rich flavor to food.

To Use Chinese Dried Mushrooms Soak the mushrooms in a bowl of warm water for about 20 minutes, or until they are soft and pliable. Squeeze out the excess water and cut off and discard the woody stems. Only the caps are used.

The soaking water can be saved and used in soups or for cooking rice. Strain through a fine sieve to discard any sand or residue from the dried mushrooms. Dried mushrooms are particularly useful if you are in a hurry and do not have time to make a stock. Their presence will cover a multitude of omissions.

NOODLES

In China, you will see people eating noodles of all kinds, day and night, in restaurants and at food stalls. They provide a nutritious, quick, light snack and usually are of good quality. There are several styles of noodles that are ideal for quick and easy cooking, such as the fresh thin egg noodles that are browned on both sides. Thin dried rice noodles are much savored also, as are the fresh ones that are readily available in Asian markets here. Below is a list of the major types of noodles that can be bought in this country.

Wheat Noodles and Egg Noodles

These are made from hard or soft wheat flour and water. If egg has been added, the noodles are usually labeled "egg noodles." They can be bought dried or fresh from Asian markets, many supermarkets, and delicatessens. Flat noodles are usually used in soups, and rounded noodles are best for stirfrying or pan-frying. The fresh ones can be frozen successfully if they are first well wrapped. Thaw them thoroughly before using.

To Cook Wheat and Egg Noodles Wheat and egg noodles are very good blanched and served with a main dish instead of plain rice. Dried wheat or fresh egg noodles are best. Allow ½ pound fresh or dried Chinese egg or wheat noodles per person. To prepare fresh noodles, immerse them in a pan of boiling water and cook for 3 to 5 minutes, or until done to your taste. To prepare dried noodles, cook either according to the instructions on the package or in boiling water for 4 to 5 minutes. Then drain and serve.

If you are cooking noodles ahead of time in advance of serving them or before stir-frying them, toss the cooked drained noodles in 2 teaspoons of sesame oil and put them into a bowl. Cover this with plastic wrap and refrigerate. The cooked noodles will remain usable for about 2 hours.

Rice Noodles

Rice noodles are popular in southern China. I find them a great convenience, as, being dried, they do not need refrigeration and are quickly prepared for a fast meal. They are available from Asian markets and are called *rice stick noodles* or *vermicelli*. They are flat and about the length of a chopstick. They can also vary in thickness; use the type called for in the recipes. *Rice sticks* are the same as rice stick noodles, but they are wider and coiled, not flat. Rice noodles are very easy to use and inexpensive. Simply soak them in warm water for 20 minutes until they are soft. Drain them in a colander or a sieve and then use them in soups or stir-fried dishes.

Bean Thread (Transparent) Noodles

These noodles, also called *cellophane noodles*, are made not from a grain flour but from ground mung beans. They are available dried and are very fine and white. Easy to recognize in their neat, plastic-wrapped bundles, they are

stocked by most Asian markets and some supermarkets. They are never served on their own, but are added to soups or braised dishes or are deepfried and used as a garnish; they are suitable for a quick meal. They must be soaked in warm water for about 5 minutes before use. As they are rather long, you might find it easier to cut them into shorter lengths after soaking. If you intend to fry them, they need first to be separated. They are quite brittle, so a good technique is to separate the strands inside a large paper bag to keep them from flying all over the place. If you are going to fry them, do not soak them before use.

OILS

Oil is the most commonly used cooking medium in Chinese cooking, and the favorite is peanut oil. Animal fats, usually lard and chicken fat, are also used in some areas. I prefer to cook with peanut oil, as I find animal fats in general too heavy.

Oil can be reused after frying. When this is possible, simply allow the oil to cool after use and filter it through cheesecloth or a fine strainer into a jar. Cover it tightly and store in a cool, dry place. If you keep it in the refrigerator it will become cloudy, but it will clarify again when it returns to room temperature. From the point of view of flavor, I find it is best to reuse oil no more than once, and this is also healthier since reused oils increase in saturated fat content. However, for real clarity of flavor, I prefer *not* to reuse oil; ideally oil should be *always* fresh as this helps achieve consistently high-quality results in cooking.

Corn Oil

Corn oil is a healthful, mostly polyunsaturated oil that is good for cooking, particularly deep-frying, as it can be heated to a high temperature without burning. However, I find it rather heavy, with a noticeable smell and taste.

Other Vegetable Oils

Some of the cheaper vegetable oils include soybean, safflower, and sunflower. They are light in color and taste and can also be used in cooking.

Peanut Oil

This is the preferred oil used in Chinese cooking because it has a pleasant, mild, and unobtrusive taste. Its ability to be heated to a high temperature without burning makes it perfect for stir-frying and deep-frying. The peanut oils found in China are cold pressed and have the fragrance of freshly roasted peanuts. Some Asian markets stock the Hong Kong brands labeled in Chinese only; these are well worth searching for. But if you cannot find them, use peanut oil from your local supermarket.

Toasted Sesame Oil

This thick, rich, golden brown or dark-colored oil is made from toasted sesame seeds and has a distinctive, nutty flavor and aroma. It is widely used in Chinese cooking in limited amounts in marinades or as a final seasoning; it is added at the end of cooking to enrich a dish subtly without overcoming its basic flavor. It is not normally used as a cooking oil with other oils except in northern China. It is sold in bottles in many supermarkets and in Asian markets.

OYSTER SAUCE, see Thick Sauces and Pastes

PEANUT OIL, see Oils

RICE

Long-Grain Rice

This is the most popular rice for cooking in southern China. The Chinese go through the ritual of washing it, but in the case of rice purchased at a supermarket, this step can be omitted for quick cooking. One of my favorite rices is the long-grain perfumed variety from Thailand, which has a pleasing fragrance, like that of Indian basmati rice. Thai aromatic long-grain rice is now available at many Asian markets.

Short-Grain Rice

Short-grain rice is not as frequently used in Chinese cooking except for making morning rice porridge. It is more popular in Japan. Suitable brands that can be found in many Asian markets are known as American Rose or Japanese Rose. Short-grain rice is slightly stickier than long-grain white rice.

Rice Wine

An important contributor to the flavors of Chinese cuisine, this wine is used extensively for cooking and drinking throughout the country. There are many varieties, but the finest is believed to be that from Shaoxing in Zhejiang Province, in eastern China. It is made from glutinous rice, yeast, and spring water. Chefs frequently use rice wine not only for cooking but also in marinades. It is now readily available from Asian markets and some wine shops. Store it, tightly corked, at room temperature. A good-quality, pale, dry sherry can be substituted for Chinese rice wine but cannot equal its rich, mellow taste. Do not confuse this wine with sake, which is the Japanese version of rice wine and quite different. Western grape wines are not an adequate substitute, either.

SALTED BLACK BEANS, see Black Beans, salted.

SESAME PASTE, see Thick Sauces and Pastes

SHALLOTS

Shallots are mild-flavored members of the onion family. They are small—about the size of pickling onions—with copper-red skins, and should be peeled before use just like onions. They have a distinctive onion taste without being as strong or overpowering as ordinary onions, and I think they are an excellent substitute for the smaller Chinese shallots, which can sometimes be found in Asian markets. Buy shallots at supermarkets and keep them in a cool, dry place (not the refrigerator).

SNOW PEAS (Pisum sativum)

This familiar vegetable combines a tender, crisp texture with a sweet, fresh flavor and cooks quickly. It is perhaps best when simply stir-fried with a little oil and salt and pieces of garlic and ginger. Frequently snow peas are combined with meats. They are readily available from supermarkets and produce stores. Look for pods that are firm, with very small peas, which means they are tender and young. They keep for at least a week, loosely wrapped, in the vegetable compartment of the refrigerator.

SOY SAUCES

Soy sauce is an essential ingredient in Chinese cooking. It is made from a

mixture of soybeans, flour, and water, which is then naturally fermented and aged for some months. The distilled liquid is soy sauce. New versions containing less salt are now available. There are two main types:

Light Soy Sauce

As the name implies, this is light in color, but it is full of flavor and is the best one to use for cooking. It is saltier than dark soy sauce. It is known in Asian markets as Superior Soy.

Dark Soy Sauce

This sauce is aged much longer than light soy sauce, hence its darker, almost black color. It is slightly thicker and stronger than light soy sauce and is more suitable for stews. I prefer it to light soy as a dipping sauce. It is known in Asian markets as Soy Superior Sauce, and, although used less frequently, it is nevertheless important to have on hand.

SUGAR

Sugar has been used sparingly in the cooking of savory dishes in China for 1,000 years. Properly employed, it helps balance the various flavors of sauces and other dishes. Chinese sugar comes in several forms: as rock or yellow lump sugar, as brown sugar slabs, and as maltose, or malt sugar. I particularly like to use rock sugar, which is rich and has a more subtle flavor than refined granulated sugar. It also gives a good luster or glaze to braised dishes and sauces. You can buy it in Asian markets, where it is usually sold in packages. You may need to break the lumps into smaller pieces with a wooden mallet or rolling pin. If you cannot find it, use granulated sugar or coffee sugar crystals (the amber, chunky kind) instead. For fast cooking, use granulated sugar.

THICK SAUCES AND PASTES

Quick and easy cooking involves a number of thick tasty sauces or pastes. These are essential to the authentic taste of the food, and it is well worth making the effort to obtain them. Most are now easy to find; they are sold in bottles or cans in Asian markets and some supermarkets. Canned sauces, once opened, should be transferred to screw-top glass jars and kept in the

Basic Chinese Pantry 21

refrigerator, where they will last indefinitely. Using these sauces results in delicious foods with little effort.

Chili Bean Paste

This thick dark paste or sauce, made from soybeans, chilies, and other seasonings, is very hot and spicy. Formerly used in cooking only in western China, it is now used throughout the country and is usually available here in jars. Be sure to seal the jar tightly after use and store in the refrigerator. Do not confuse chili bean paste with chili sauce, which is hot, red, thinner, and made without beans and is used mainly as a dipping sauce for cooked dishes. There are Southeast Asian versions of chili bean pastes (called sate sauce) which I find very spicy and hot. You can use them as a substitute for chili bean paste if you like really spicy food.

Hoisin Sauce

Widely used in this book, this thick, dark, brownish red sauce is made from soybeans, vinegar, sugar, spices, and other flavorings. Sweet and spicy, it is a very popular ingredient in southern Chinese cooking. In the West, it is often used as a sauce for Peking duck instead of the traditional sweet bean sauce. Hoisin sauce (sometimes also labeled "barbecue sauce") is sold in cans and jars. When refrigerated, it keeps indefinitely.

Oyster Sauce

This is one of my favorite sauces for quick cooking. It is easy to make a delicious sauce in no time at all using oyster sauce, which gives a rich aroma to a dish. Thick and brown, it is made from a concentrate of oysters cooked in soy sauce, seasonings, and brine. Despite its name, oyster sauce does not taste fishy. It has a rich flavor and is used not only in cooking but as a condiment, diluted with a little oil, for vegetables, poultry, or meat; it is very versatile. It is usually sold in bottles and can be bought in Asian markets and some supermarkets. Look for the most expensive ones as they are the highest in quality. Keep refrigerated after opening.

Sesame Paste

This rich, thick, creamy brown paste is made from toasted sesame seeds, unlike the Middle Eastern tahini. It is sold in jars in Asian markets. If oil has separated from the paste in the jar, empty the contents into a blender or food processor and mix well. Chinese sesame paste is used in both hot and cold dishes, and is particularly popular in northern and western China. It is sold in jars at Asian markets. If you cannot obtain it, use a smooth peanut butter instead.

Yellow Bean Sauce

This thick, spicy, aromatic sauce is made with yellow beans, flour, and salt fermented together. It is quite salty but adds a distinctive flavor to sauces and is frequently used in Chinese cooking. There are two forms: whole beans in a thick sauce, and mashed or pureed beans (sold as crushed yellow bean sauce). I prefer the whole-bean variety because it is slightly less salty and has a better texture. It keeps indefinitely in the refrigerator and can be found at Asian markets.

TOASTED SESAME OIL, see Oils

VINEGARS

Vinegars are widely used in China as dipping sauces as well as for cooking. Unlike Western vinegars, they are usually made from rice. There are many varieties, ranging in flavor from the spicy and slightly tart to the sweet and pungent. Experiment with them. They keep indefinitely.

Black Rice Vinegar

Black rice vinegar is very dark in color and slightly sweet although mild in taste. It is used for braised dishes, noodles, and sauces.

White Rice Vinegar

White rice vinegar is clear and mild in flavor. It has a faint taste of glutinous rice and is used for sweet and sour dishes.

YELLOW BEAN SAUCE, see Thick Sauces and Pastes

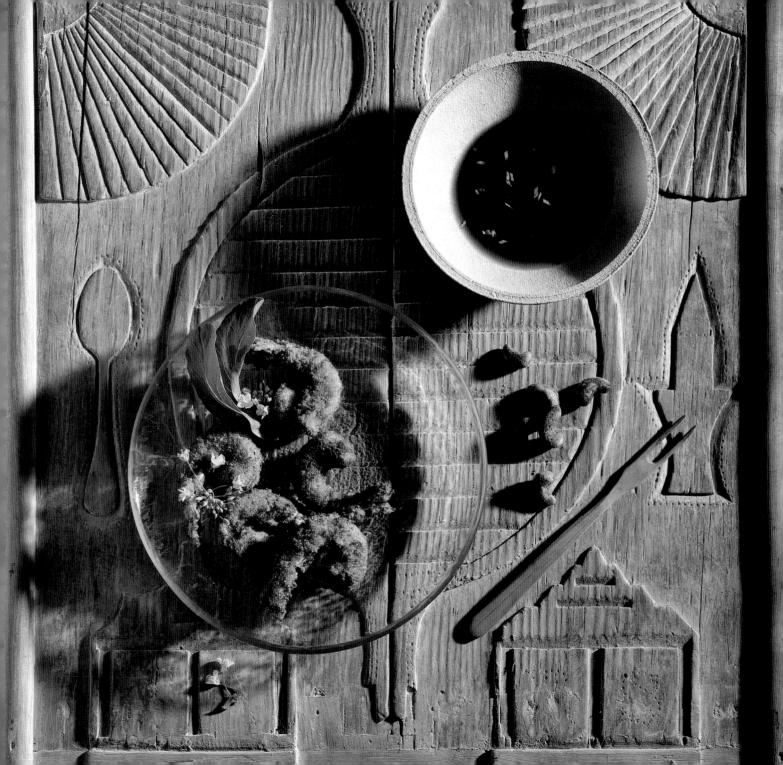

Spicy Fried Cashew Nuts Page 26

Crispy Prawns Page 32

Appetizers & First Courses

It may seem a contradiction in terms to have appetizers and first courses in a quick and easy cookbook, but there is a place for them—as long as they are quick and easy. These recipes fit that description, for they are simple but delicious. The cooking techniques include grilling, stir-frying, deep-frying, and no cooking at all! When time is a factor, I prefer appetizers and first courses that can be done in advance and then finished at the last moment, quickly and easily.

Remember, too, that these very same dishes can be prepared as part of a more elaborate meal when you have more time at your disposal. Alternatively, you could serve some of the main-course dishes in smaller quantities as appetizers. It is nice to have different tastes and textures within one meal. The reasoning behind this cookbook is that quick and easy should mean "pleasing and delicious."

- I. Spicy Fried Cashew Nuts
- 2. Cold Cucumber Salad
- 3. Chinese Barbecued Chicken Wings
- 4. Minced Prawns with Lettuce Leaves
- Grilled Prawns with Cilantro and Ginger Sauce
- 6. Crispy Prawns

Spicy Fried Cashew Nuts

Shopping List ½ pound raw cashew nuts

Preparation Time: 8 minutes Cooking Time: 6 minutes Makes: ½ pound

1 1/4 cups peanut oil
1/2 pound raw cashew nuts
1 teaspoon salt
1/2 teaspoon freshly ground black pepper
1/2 teaspoon cayenne
1/4 teaspoon five-spice powder Many Hong Kong restaurants serve small platters of stir-fried or deep-fried peanuts with seasoned salt as an appetizer. I have always enjoyed them, and they should be a part of everyone's repertoire of starters. Here I use cashews, my favorite nuts. Their flavor stands up very nicely to the robustness of the spices. Easily made in advance, they go well with drinks and can be served warm or cold.

R E C I P E

Heat a wok or large skillet, then add the oil. When the oil begins to smoke lightly, deep-fry the cashew nuts for 2 minutes, or until they begin to turn slightly brown. While the nuts are browning, start to heat another skillet. Remove the nuts from the oil with a slotted spoon when they are lightly toasted. Do not allow them to brown very deeply, as they will continue cooking even after they have been taken out of the oil. Add the nuts directly to the hot skillet. Add the salt, pepper, cayenne, and five-spice powder and stir-fry for 2 minutes, or until the cashew nuts are well coated with the spices. Allow to cool before serving with drinks.

Cold Cucumber Salad

Here is a really quick and easy recipe in which you salt the cucumbers and sweat the moisture from them for 15 minutes. They acquire a cooked texture without cooking and make a charming first course. They can also serve as a picnic dish or as part of a summer salad. Garnish with blanched red bell pepper strips, if you wish to add a note of color.

R E C I P E

Peel the cucumbers and slice them in half lengthwise. Using a teaspoon, remove the seeds. Cut the cucumbers halves into 3-by-½-inch pieces and put them into a colander set inside a bowl. Sprinkle the pieces with the salt, mix well, and set aside for 15 minutes.

Next, combine the sauce ingredients thoroughly in a small bowl and set aside. Rinse the cucumber pieces, pat them dry with paper towels, and mix with the sauce. Let them marinate for 10 minutes. Garnish with the pepper strips, if desired.

Shopping List

1 pound cucumbers 1 large shallot 1 fresh red hot chili Garlic

Preparation Time: 30 minutes

Cooking Time: None

Serves: 4 to 6

I pound cucumbers 2 teaspoons salt

Sauce

I tablespoon finely chopped shallots
2 teaspoons finely chopped garlic
I teaspoon light soy sauce
I teaspoon dark soy sauce
2 tablespoons white rice vinegar
2 teaspoons sugar
I small fresh red chili, finely chopped
I tablespoon toasted sesame oil
Blanched red pepper strips
(optional)

Chinese Barbecued Chicken Wings

Shopping List 2 pounds chicken wings Garlic Fresh ginger

Preparation Time: 10 minutes Cooking Time: 35 minutes Serves: 4

2 pounds chicken wings

Barbecue Sauce

2 tablespoons dark soy sauce
3 tablespoons hoisin sauce
2 large garlic cloves, peeled
I tablespoon chopped peeled fresh ginger
I tablespoon rice wine or dry sherry
I tablespoon toasted sesame oil
2 teaspoons chili bean paste
2 teaspoons sugar

Thinese cuisine offers some of the most delicious and stimulating of barbecue sauces. Of course, I might be biased on the matter. There can be little doubt that the sauces are easy to prepare. I like to use this combination of sauces with chicken wings, a cheap and humble food that is thereby transformed into a delightful dish. If you wish, you can substitute chicken breasts, but cook them for less time. Serve these tasty morsels with drinks; the quantities given below are for a large group, but for an even bigger gathering, simply double or triple the ingredients. The chicken wings take a few minutes to cook but need no watching and you can, meanwhile, be about other things. Serve them hot or let them cool to room temperature; they are quite as wonderful after they have cooled and thus make a most appropriate picnic dish.

If it helps your schedule, you can prepare the wings and sauce on the morning of the day you intend to cook them. Leave them covered with plastic wrap in the refrigerator, but be sure to bring them to room temperature before cooking. As a further time saver, make a double batch of barbecue sauce and use half of it later in the week to accompany grilled lamb or pork chops.

R E C I P E

Preheat the oven to 475°. Place the chicken wings in an ovenproof baking dish. Combine the barbecue sauce ingredients in a blender and mix for 5 seconds. Add the sauce to the chicken wings and toss to coat thoroughly. Place the wings in the oven and cook for 15 minutes. Turn the heat down to 350° and cook for a further 20 minutes. Serve hot or allow to cool and serve at room temperature.

Minced Prawns with Lettuce Leaves

This elegant dish is derived from a more sumptuous one that uses lobster as its main ingredient. No matter; prawns are a perfectly acceptable substitute. In fact, prawns are ideal for quick and easy meals because they need only a short cooking time—in this case 5 to 6 minutes. It is a colorful dish with contrasting textures and is an impressive first course for any meal; but it may also serve as a refreshing light lunch. Other vegetables in season, such as carrots or zucchini, may be substituted for the red peppers or asparagus and cooked in the same way.

Shopping List

1 pound iceberg lettuce ½ pound fresh raw prawns ½ pound red bell peppers ¼ pound asparagus Fresh ginger Green onions Garlic

Preparation Time: 15 to 20 minutes
Cooking Time: 5 to 6 minutes
Serves: 4

R E C I P E

Separate, wash, and dry the lettuce leaves. Peel the prawns and discard the shells. Using a small sharp knife, partially split the prawns lengthways and remove the fine digestive cord—if you are particularly short of time you can omit this step. Pat the prawns dry with paper towels and coarsely chop them.

Finely dice the peppers and asparagus and set aside. Heat a wok or large skillet, and add the oil. Add the garlic, ginger, and green onions and stir-fry for 10 seconds. Add the diced vegetables and continue to stir-fry for 3 minutes. Add the prawns, salt, soy sauce, and sesame oil and continue to cook for 2 minutes.

Turn the mixture onto a serving plate. Arrange the lettuce on a separate plate, put the hoisin sauce in a small bowl, and serve. Each guest puts a heap of each ingredient on a lettuce leaf, wraps it up, and eats it with the fingers.

- I pound iceberg lettuce, about I small head
- ½ pound fresh raw prawns
- 1/2 pound red bell peppers, cored and seeded
- 1/4 pound asparagus, trimmed 1/2 tablespoons peanut oil
- 2 tablespoons coarsely chopped garlic
- 2 tablespoons chopped peeled fresh ginger
- 1/4 cup coarsely chopped green onions
- I teaspoon salt
- 2 teaspoons light soy sauce
- 2 teaspoons toasted sesame oil
- 1/4 cup hoisin sauce

Cold Cucumber Salad Page 27

Grilled Prawns with Cilantro and Ginger Sauce

Prawns make a wonderful appetizer because they are easy to prepare and are popular with most people. They may seem expensive, but a little goes a long way and they certainly whet the appetite. Most of the work in this recipe may be done well in advance; the actual cooking takes but 5 minutes and the shellfish emerge from under the grill redolent of cilantro and tangy ginger, an ideal appetizer for guests.

These prawns cook wonderfully on a grill but I have found that they are just as tasty when broiled, so, if the weather turns inclement, you can move indoors and still enjoy them. If you plan a larger gathering, the quantities given in the recipe may be increased several times. Moreover, these prawns may serve as an elegant cold buffet dish or, if you wish, as a quick and easy lunch.

R E C I P E

Preheat the broiler or light a fire in an open grill. Peel the prawns and discard the shells. Using a small sharp knife, partially split the prawns lengthways and remove the fine digestive cord—if you are particularly short of time you can omit this step. Pat the prawns dry with paper towels.

Combine the marinade ingredients, add the prawns, and set aside for 10 minutes. Prepare the sauce ingredients, mix them together, and set aside.

Lay the prawns on a baking tray big enough to fit under the broiler. Alternatively, cook them on a grill over gray coals, weather permitting. Cook the prawns for 3 minutes on one side, turn over, and cook for 2 minutes on the other side. Place on a serving platter and serve with the sauce.

Shopping List

1 pound fresh raw prawns Fresh ginger Cilantro

Preparation Time: 30 minutes Cooking Time: 5 minutes

Serves: 2 to 4

I pound fresh raw prawns

Marinade

I tablespoon light soy sauce
I teaspoon rice wine or
dry sherry
I teaspoon toasted sesame oil

Sauce

2 tablespoons minced fresh cilantro2 teaspoons white rice vinegar1 teaspoon chopped peeled fresh ginger

Crispy Prawns

Shopping List
1 pound fresh raw prawns
Bread crumbs

Preparation Time: 25 minutes Cooking Time: 3 to 4 minutes Serves: 6 to 8 as a first course

I pound fresh raw prawns
2 teaspoons light soy sauce
I tablespoon rice wine or
dry sherry
I teaspoon five-spice powder
1/4 teaspoon freshly ground
black pepper
2 cups peanut oil
1/2 cup cornstarch
2 eggs, beaten
2/3 cup bread crumbs

During one of my many trips to Australia, Charmaine Solomon, an authority on Asian cuisines, introduced me to this dish. It is to be found in one of her delightfully written cookbooks, and I unabashedly borrow it and share it with you. The prawns are so good that they could serve as a main course, and they are so tasty that no dipping sauce is needed.

R E C I P E

Peel the prawns and discard the shells. Using a small, sharp knife, partially split the prawns lengthwise and remove the fine digestive cord—if you are particularly short of time, you can skip this step. Pat the prawns dry with paper towels. Place the prawns in a bowl and mix with the soy sauce, rice wine, five-spice powder, and pepper.

Heat a wok or large, deep skillet, then add the oil. While the oil is heating, dip the prawns in the cornstarch, shaking them gently to remove any excess, then dip them into the beaten eggs, and finally coat them thoroughly with the bread crumbs. A clean and easy way to do this is to place the cornstarch and bread crumbs in two separate plastic or paper bags. Toss the prawns gently in the first bag with the cornstarch, remove them, and put them in the bowl with the beaten eggs, making sure that they are well coated. Then transfer them with a slotted spoon to the bag containing the bread crumbs and toss gently.

When the oil begins to smoke slightly, deep-fry the coated prawns for 3 to 4 minutes or until they are golden brown. Drain them well on paper towels and serve at once.

Quick and Easy Chicken Stock Page 36

Oups cannot be made quickly and still taste as they should; you must use decent stock. Soup made with water is insipid—unless it is fish soup, in which case the assertive sea flavor enlivens the water. Preservatives and artificial flavorings keep me away from most commercial canned and cubed stocks. Thus this section proposes something of a compromise. Instead of the traditional long-simmering stock, I use a more quickly made stock that is nevertheless homemade and of very good quality, which matters even more when you are in a hurry. Once the stock is made and frozen, you have at hand the basis of quick and easy soups.

- I. Quick and Easy Chicken Stock
- 2. Chicken and Watercress Soup
- 3. Chicken with Rice Noodles in Soup
- 4. Tomato-Ginger Soup
- 5. Tri-Color Soup
- 6. Whole Fish Soup
- 7. Fast Seafood Soup
- 8. Rich Beef Soup

Quick and Easy Chicken Stock

Shopping List 2 pounds chicken wings Green onions

Fresh ginger Garlic

Preparation Time: 20 minutes **Cooking Time:** 1 hour

Makes: 2 pints

2 pounds chicken wings
6 cups water
One I ½-inch piece peeled fresh ginger
4 green onions
2 large unpeeled garlic cloves
2 teaspoons salt

There is no comparison between stock made from scratch and the commercially available kind. Even if you are usually pressed for time, take the time to prepare this stock in advance for soups that will then be quick, easy, and delicious. Twenty minutes of work and an hour of simmering are all that you need here. Freeze the stock, and you will have the foundation for real soup. I use chicken wings because they are fast-cooking, cheap, and have a good flavor.

RECIPE

Put the chicken wings into a large saucepan. Cover with the water and bring to the simmering point.

Meanwhile, cut the ginger into $\frac{1}{2}$ -inch diagonal slices. Trim the green tops from the green onions and cut the remainder into thirds. Lightly crush the garlic cloves, leaving the skins on.

As the water in the pan begins to simmer, gently skim off the scum as it rises to the surface using a large, flat spoon. Add the green onions, ginger, garlic, and salt and partially cover. Gently simmer for 1 hour.

Strain the stock through a fine sieve. Remove any surface fat. It is now ready for use, or it can be allowed to cool thoroughly before being transferred to containers and frozen for future use.

Chicken and Watercress Soup

I was fortunate to have a mother who was a good cook. Because she worked out of the home, however, she by necessity made an art of quick and easy meals, especially soups. This delectable chicken and watercress soup was a family favorite. The mushrooms add substance as well as an earthy flavor, but if you are really in a hurry, they may be omitted. I highly recommend that you include them, however; the few minutes' extra time is well worth it. If you like, you can substitute spinach for the watercress.

Shopping List

3/4 pound boneless chicken breasts 1/2 pound watercress

Preparation Time: 12 minutes Cooking Time: 12 minutes

Serves: 4 to 6

R E C I P E

Soak the dried Chinese mushrooms in warm water for about 15 minutes. Meanwhile, shred the chicken breasts and combine them with ½ teaspoon of the salt, the rice wine, and cornstarch. Wash the watercress, discarding any tough stems.

Put the stock into a medium-sized saucepan and bring to the simmering point. While the stock is heating, remove the mushrooms from the water and squeeze out any excess liquid. Cut off the stalks and discard them. Add the mushrooms to the simmering stock and continue to cook for 5 minutes. Now add the chicken and watercress, turn off the heat, and add the remaining I teaspoon salt and the sesame oil. Give the soup several stirs and allow it to stand for 2 minutes before serving.

1/2 ounce dried Chinese mushrooms 3/4 pound boneless chicken breasts 1 1/2 teaspoons salt 1 teaspoon rice wine or dry sherry 1 teaspoon cornstarch 1/2 pound watercress 5 cups chicken stock 2 teaspoons toasted sesame oil

Soups 37

Tri-Color Soup Page 41

Chicken with Rice Noodles in Soup

With your stock ready-made and waiting in the freezer, this dish is quick and easy to prepare. It is comforting, satisfying, real food, perfect for a cold winter's day when you do not have time for involved shopping and the pickings are slim because of the weather. It is both filling and light at the same time. Add other vegetables for a more substantial meal—snow peas are perfect and need only be trimmed before being blanched in the hot stock. If you like spicy soup, as I do, stir in a teaspoon or two of chili bean paste and perhaps 1½ teaspoons lemon or lime juice.

Shopping List 1/4 pound boneless chicken breast Green onions

Preparation Time: 5 minutes **Cooking Time:** 10 minutes

Serves: 4 to 6

R E C I P E

In a medium saucepan, bring the chicken stock to a simmer. Finely shred the chicken breast. Add the chicken and rice noodles to the stock and simmer for 5 minutes, or until the chicken is just cooked through. Add the salt and sesame oil, sprinkle the green onions over the top, and serve at once.

5 cups chicken stock 1/4 pound boneless chicken breast 1/4 pound dried rice stick noodles I teaspoon salt

2 teaspoons toasted sesame oil 2 green onions, finely chopped

39

Tomato-Ginger Soup

Shopping List 1 pound fresh or canned tomatoes Fresh ginger

Preparation Time: 9 minutes Cooking Time: 6 minutes

Serves: 4 to 6

 pound fresh or canned tomatoes
 cups chicken stock
 tablespoons chopped peeled fresh ginger
 tablespoon light soy sauce
 teaspoons chili bean paste
 teaspoons sugar This soup is a year-round favorite of mine because it can be made successfully with canned tomatoes, one of the few processed foods I find acceptable, so you need not wait for fresh tomatoes to come into season. Of course, it is delicious made with fresh ripe tomatoes when they are available at a reasonable price, and they also need little preparation and cook quickly. This is a refreshing soup that makes a sparkling first course. On hot summer days, try serving it at room temperature. For a Southeast Asian touch, add 2 tablespoons lemon juice. The soup reheats successfully.

R E C I P E

If you are using fresh tomatoes, cut them in half horizontally and squeeze out the seeds. Coarsely chop the flesh and set aside. If you are using canned tomatoes, drain thoroughly and chop them roughly.

Put the stock into a large saucepan and bring to the simmering point. Add the ginger, soy sauce, chili bean paste, sugar, and tomatoes. Simmer for 2 minutes. Serve at once.

Tri-Color Soup

Perfect for a holiday, or any other day, this colorful and appetizing soup is as delicious and nutritious as it looks: it is refreshing, light, and full of flavor. It makes a perfect first course and can double as a main dish for a quick family meal. Other vegetables in season, such as bok choy, Napa cabbage, or Swiss chard, may replace the spinach.

R E C I P E

If you are using fresh tomatoes, cut them in half horizontally and squeeze out the seeds. If you are using canned tomatoes, drain them. Coarsely chop the flesh and set aside. Cut the bean curd into $\frac{1}{2}$ -inch squares. Remove the stalks from the spinach and wash the leaves well.

Bring the stock to a simmer in a medium saucepan. Add the tomatoes, bean curd, and spinach, and simmer for 2 minutes. Then add the soy sauce, pepper, sugar, and vinegar. Give the soup several gentle stirs and serve at once.

Shopping List

½ pound fresh or canned tomatoes

½ pound firm bean curd

½ pound fresh spinach

Preparation Time: 17 minutes **Cooking Time:** 6 minutes

Serves: 4 to 6

1/2 pound fresh or canned tomatoes

½ pound firm bean curd

½ pound fresh spinach

5 cups chicken stock

I tablespoon light soy sauce

½ teaspoon freshly ground white or black pepper

1/2 teaspoon sugar

½ teaspoon white rice vinegar

Soups 41

Whole Fish Soup

Shopping List

1 to 1½ pounds whole fish or fish fillets, preferably sea bass, cod, or haddock ½ pound celery Fresh ginger Green onions

Preparation Time: 15 minutes Cooking Time: 10 minutes, plus 10 minutes' standing time Serves: 4 to 6

I to I ½ pounds whole fish or fish fillets, preferably sea bass, cod, or haddock

6 cups water

1 1/2 teaspoons salt

1/4 cup finely shredded peeled fresh ginger

½ pound celery, trimmed and coarsely chopped

I tablespoon light soy sauce

I tablespoon rice wine or dry sherry

4 green onions, shredded I tablespoon toasted sesame oil This elegant fish soup is taken from the menu of the Chiu Chow Garden restaurant in Hong Kong. I first tasted it there in the company of Jeff Smith, the "Frugal Gourmet," and perhaps America's best-known television cook. It is a most impressive dish to serve when you are entertaining and are short of time to prepare food. A whole fish brings good luck, the Chinese say. What is certain is that it brings good taste to soup.

If you wish, you can serve the fish with a dipping sauce of soy sauce, chopped green onions, and finely sliced fresh ginger, and serve the soup separately.

R E C I P E

If you are using a whole fish, clean it and remove the gills. Either leave the head on as the Chinese do or remove it if you prefer. If you are using fish fillets, remove the skin. Wash the fish thoroughly. Using a sharp knife or cleaver, cut diagonal slices across either side of the whole fish or on one side of the fillets. Do not cut right through, but keep the fish or fillets intact.

Bring the water to a simmer in a saucepan and gently lower in the fish. Simmer for 2 minutes and add all the rest of the ingredients except the sesame oil. Cover and simmer for another 8 minutes. Turn off the heat and leave the soup to stand for 10 minutes. Just before serving, stir in the sesame oil.

Fast Seafood Soup

hen you really don't have time, there is no stock in your freezer, and you want a change of pace, do as some Chinese families do: use fish to make a quick seafood soup. The assertive flavor of the fish combined with rice wine and ginger provides a tasty base. For a soup redolent of the flavor of China, add clams or mussels and prawns. This is a light but nutritious soup.

R E C I P E

Cut the fish fillets into 2-inch pieces and mix with the salt, pepper, and sesame oil.

In a medium saucepan, bring the water and rice wine to a boil for I minute and then lower the heat until the liquid is just simmering. Add the ginger, soy sauce, chili bean paste, and the fish chunks and simmer for 5 minutes, or until the fish is just cooked through. Serve at once.

Shopping List

1 pound fresh fish fillets, preferably cod or haddock Fresh ginger

Preparation Time: 10 minutes Cooking Time: 10 minutes

Serves: 4

I pound fresh fish fillets, preferably cod or haddock I teaspoon salt ½ teaspoon freshly ground white or black pepper

2 teaspoons toasted sesame oil $2\frac{1}{2}$ cups water

2/3 cup rice wine or dry sherryI tablespoon finely chopped peeled fresh ginger

I tablespoon light soy sauce I teaspoon chili bean paste

Soups 43

Rich Beef Soup

Shopping List 1/2 pound ground beef 2 eggs
Green onions

Preparation Time: 15 minutes Cooking Time: 7 minutes

Serves: 4 to 6

½ pound ground beef
I tablespoon plus 2 teaspoons dark soy sauce
2 teaspoons rice wine or dry sherry
I teaspoon cornstarch
5 cups chicken stock
I tablespoon cornstarch mixed with I tablespoon water
I teaspoon chili bean paste
½ teaspoon freshly ground white or black pepper
2 eggs, beaten
¼ cup coarsely chopped

green onions

This satisfying savory soup is perfect for those who like to make a meal of soup and salad. The beef is ground and thus cooks faster than slices or chunks would; the seasonings give it an added dimension. This soup reheats very well and can be prepared in advance. It takes 22 minutes from kitchen to table.

R E C I P E

Combine the beef with I tablespoon of the soy sauce, the rice wine, and the I teaspoon cornstarch.

Put the stock into a medium saucepan and bring to the simmering point. Add the beef and cornstarch-water mixture, and stir for 1 minute, breaking up any clumps of meat. Then add the remaining 2 teaspoons of dark soy, the chili bean paste, and pepper. Simmer for 2 minutes. Stir in the beaten eggs and finally garnish with the green onions. Serve at once.

i

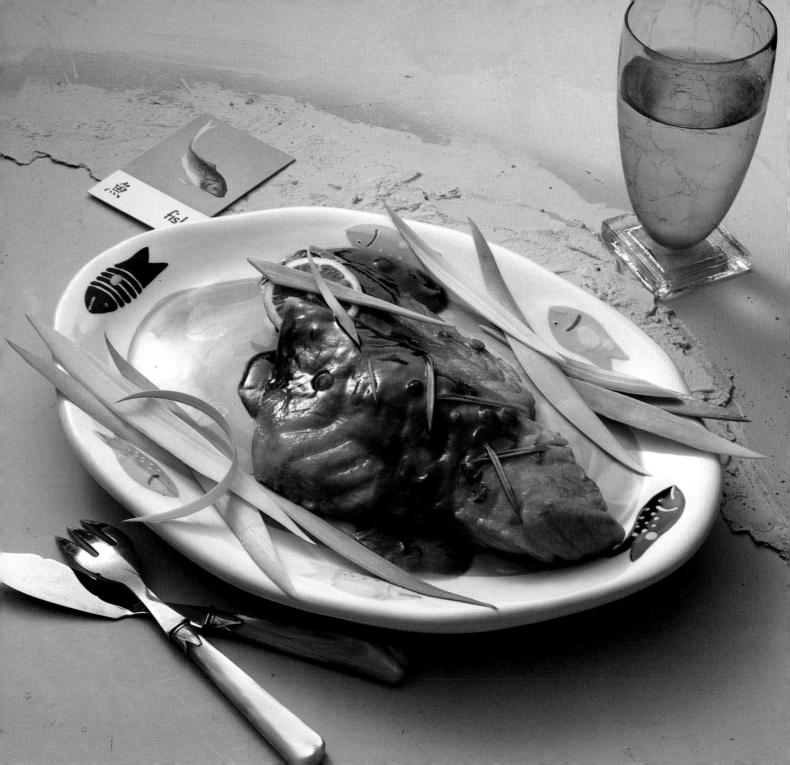

Eish and shellfish by their very nature are best when not overcooked. The sweet, succulent sea flavors are retained through careful and quick cooking. Fish is thus most appropriate for the quick and easy approach. First you must buy the freshest fish you can find; then you must cook it quickly and with the appropriate seasonings. I think that no other cuisine matches the Chinese in its ability to capture the best flavors and textures of the harvest of the sea. I draw upon that heritage in these recipes.

Firm white fish such as cod, haddock, and even sole lend themselves best to the steaming technique. This delicate process gently brings out the virtues of the food. Chinese spices such as salted black beans can be used on more assertively flavored fish, such as salmon and mussels. Ginger, garlic, and green onions are very congenial seasonings for all fish or seafood. Serve any of the following recipes with another vegetable dish and rice or potatoes and you will have the best of contemporary dining, whether you are entertaining a large party or eating informally with family and friends.

- I. Stir-fried Peppers with Scallops
- 2. Stir-fried Scallops with Leeks
- 3. Stir-fried Prawns and Peas
- 4. Prawns in Ginger Sauce
- 5. Whole Prawns Baked in Salt
- 6. Hot Pepper Prawns
- 7. Mussels in Black Bean Sauce
- 8. Fast Curried Fish Stew
- 9. Five-Minute Fish Cooked on a Plate
- 10. Quick Pan-fried Spicy Fish
- 11. Steamed Salmon with Black Bean Sauce
- Ten-Minute Poached Salmon with Green Onion Sauce
- 13. Fried Fish with Whole Garlic
- 14. Rice Wine-steeped Fish

Stir-fried Peppers with Scallops

Shopping List

1 pound fresh scallops
1/2 pound red bell peppers
1/4 pound green bell peppers
Garlic
Fresh ginger
Green onions

Preparation Time: 15 minutes Cooking Time: 8 minutes Serves: 4 to 6

Sauce

I tablespoon light soy sauce
2 teaspoons yellow bean sauce
2 tablespoons rice wine or dry sherry
I teaspoon sugar
I teaspoon toasted sesame oil

pound fresh scallops
 pound red bell peppers
 pound green bell peppers
 tablespoons peanut oil
 tablespoons coarsely chopped green onions
 tablespoon coarsely chopped garlic
 teaspoons finely chopped peeled fresh ginger

Scallops are fragile, sweetly delicate morsels and need very little preparation or cooking time. They embody all the qualities aimed for in this book, being quick, easy, and delicious. In this recipe I combine them with nutritious, tasty, and colorful red and green peppers. The result is a festive-looking dish that belies its ease of preparation; it is perfect for a family meal or as the centerpiece for a dinner party prepared at short notice.

Mussels or clams may be substituted for the scallops, and asparagus, zucchini, or snow peas for the peppers. If you like spicy food, add 2 finely sliced fresh hot chilies.

R E C I P E

Combine the sauce ingredients and set aside. Wash the scallops, pat them dry with paper towels, and set them aside. Core and seed the peppers and cut them into 1-inch squares.

Heat a wok or large skillet. Add the oil, green onions, garlic, and ginger, and stir-fry for 10 seconds. Then add the peppers and stir-fry for 2 minutes. Stir in the scallops and the sauce ingredients. Continue to cook for another 4 minutes. Serve at once.

Stir-fried Scallops with Leeks

The leek, a member of the onion family, has been used for millennia in China to flavor and enhance other foods. This scallop and leek recipe is a Shanghai-style dish popular in eastern China. Like most shellfish recipes it is simple and easy to make. The leeks need a little more cooking time than the scallops, but the combination is quite tasty. For a change, try replacing the scallops with prawns. This is a home-style meal that makes family dining something quite special.

Shopping List

1 pound fresh scallops 1 pound leeks Garlic Fresh ginger Green onions

Preparation Time: 18 minutes Cooking Time: 8 minutes

Serves: 4 to 6

R E C I P E

Mix together the sauce ingredients and set aside. If the scallops are very large, cut them in half. Dry them with paper towels and set aside. Trim the leeks and discard any blemished parts. Cut them in half at the point where they begin to turn green and discard the green part. Split the white part in half and cut it at a slight diagonal into 2-inch segments. Wash well several times in cold water.

Heat a wok or large skillet, then add the peanut oil, leeks, green onions, garlic, ginger, and salt and stir-fry for 1 minute. Add the sauce and stir-fry the mixture for 3 minutes. Lastly, add the scallops and continue to stir-fry for 4 more minutes, or until the scallops are just cooked. (They should be slightly firm to the touch; I find them at their best when they are barely cooked through.) Serve at once.

Sauce

2 tablespoons dark soy sauce 2 teaspoons chili bean paste 1 tablespoon rice wine or

dry sherry I teaspoon sugar

2 teaspoons toasted sesame oil

I pound fresh scallops
I pound leeks

11/2 tablespoons peanut oil

2 tablespoons coarsely chopped green onions

I tablespoon coarsely chopped garlic

2 teaspoons finely chopped peeled fresh ginger

1/2 teaspoon salt

49

Stir-fried Prawns and Peas

Shopping List

1 pound fresh raw prawns 1 pound fresh peas, shelled, or ½ cup frozen peas Fresh ginger Green onions

Preparation Time: 15 minutes **Cooking Time:** 4 to 5 minutes **Serves:** 2 to 4

I pound fresh raw prawns

Marinade

I teaspoon salt I teaspoon toasted sesame oil

I pound fresh peas, shelled, or ½ cup frozen peas

1½ tablespoons peanut oil
I tablespoon coarsely chopped garlic

I tablespoon coarsely chopped peeled fresh ginger

2 tablespoons coarsely chopped green onions

2 teaspoons toasted sesame oil

2 tablespoons water

Prawns are made for quick cooking. They need little preparation and cooking, and in fact overcooking can ruin their succulence and unique sea flavor. Here they are combined with one of my favorite vegetables, peas, which add color and a contrasting texture and taste to the dish. Try, as always, to obtain fresh peas; if they are not available, frozen peas work very well. For variety you could use fresh fava beans or fresh corn kernels instead of peas. This makes a superb luncheon dish accompanied with rice, or it may serve as an elegant starter for a dinner party.

R E C I P E

Peel the prawns and discard the shells. Using a small sharp knife, partially split the prawns lengthways and remove the fine digestive cord—if you are particularly pressed for time, you can skip this step. Pat the prawns dry with paper towels. Mix the marinade ingredients, combine with the prawns, and set aside.

If you are using fresh peas, blanch them in boiling water for 2 minutes, drain, and set aside. If you are using frozen peas, let them thaw at room temperature.

Heat a wok or large skillet, then add the oil. Add the garlic, ginger, and prawns and stir-fry for 30 seconds. Then add the peas and continue to stir-fry for I minute. Add the green onions and toasted sesame oil. Add the water and continue to stir-fry another 2 minutes. Serve at once.

Prawns in Ginger Sauce

A gain, one of my quick and easy favorites, prawns—this time with a zesty ginger sauce to make a spicy and refreshing treat. This delightful and visually attractive dish can be served over rice for a one-dish meal that will satisfy both the stomach and the palate. It can double as a first course for a dinner party.

Shopping List

1 pound fresh raw prawns Fresh ginger Cilantro

Preparation Time: 20 minutes **Cooking Time:** 4 minutes

Serves: 4

R E C I P E

Mix together the sauce ingredients and set aside. Peel the prawns and discard the shells. Using a small sharp knife, partially split the prawns lengthwise and remove the fine digestive cord—if you are particularly short of time you can omit this step. Pat the prawns dry with paper towels and combine them with the salt, cornstarch, and the I teaspoon toasted sesame oil.

Heat a wok or large skillet, then add the peanut oil, prawns, and ginger. Stir-fry the mixture for 30 seconds. Then add the sauce ingredients and continue to cook for 2 minutes. Serve at once.

Sauce

- 2 tablespoons rice wine or dry sherry
- I tablespoon light soy sauce
- I tablespoon water
- 1/2 teaspoon salt
 I teaspoon sugar
- 2 tablespoons finely chopped fresh cilantro
- 2 teaspoons toasted sesame oil
- I pound fresh raw prawns
- I teaspoon salt
- I teaspoon cornstarch
- I teaspoon toasted sesame oil
- 1 1/2 tablespoons peanut oil
- 3 tablespoons finely chopped peeled fresh ginger

Whole Prawns Baked in Salt

Shopping List

1 pound fresh raw prawns 1 pound coarse sea salt Fresh ginger

Preparation Time: 10 minutes Cooking Time: 10 minutes

Serves: 4

Dipping Sauce

3 tablespoons finely chopped peeled fresh ginger 5 tablespoons black rice vinegar

I pound fresh raw prawns I pound coarse sea salt This does not produce a salty dish. Rather, the salt, being very hot, cooks the unpeeled prawns quickly with just the right amount of savor. The result is very fresh-tasting prawns, with a special aroma ready for the contrasting flavors of the dipping sauce. Serve the cooked prawns immediately so that they do not absorb too much salt, and let your guests peel their own. This dish is perfect for a large crowd.

R E C I P E

Combine the dipping sauce ingredients and set aside. Rinse the whole prawns thoroughly under cold running water. Do not peel. Pat the prawns dry with paper towels.

Heat a wok or large skillet, then add the sea salt. Heat the salt until it is very hot and popping, then add the prawns and stir, mixing them thoroughly with the salt. When the prawns are pink and firm, they are cooked. This should take about 5 to 8 minutes. Immediately remove the prawns from the skillet, shaking off any excess salt. Serve at once with the dipping sauce.

Hot Pepper Prawns

I was introduced to this dish one evening when I dined with Madhur Jaffrey and her husband at the Shun Lee Palace restaurant in New York. She suggested that I try it, predicting that I would appreciate the imaginative interplay of pungent aromas and spicy flavors. How right she was. This is an exciting treat for the tastebuds and very easy to prepare. Serve it with rice. For a one-dish meal, double the quantity of sauce and toss the sauce and prawns with fresh egg noodles or rice noodles.

Shopping List
1 pound fresh raw prawns
2 fresh hot chilies
Garlic

Green onions

Preparation Time: 18 minutes Cooking Time: 4 minutes

Serves: 4

R E C I P E

Peel the prawns and discard the shells. Using a small sharp knife, partially split the prawns lengthwise and remove the fine digestive cord—if you are particularly pressed for time, you can omit this step. Pat the prawns dry with paper towels and combine with the salt, cornstarch, and toasted sesame oil and mix well.

Heat a wok or large skillet and add the peanut oil and prawns. Stir-fry for I minute, then remove the prawns with a slotted spoon. To the remaining oil, add the chilies, black beans, garlic, and green onions. Stir-fry for 20 seconds and add the vinegar, soy sauce, and sugar. Stir in the cornstarch mixture and return the prawns to the wok. Cook for another 2 minutes and serve at once.

I pound fresh raw prawns

I teaspoon salt

2 teaspoons cornstarch

2 teaspoons toasted sesame oil

2 tablespoons peanut oil

2 fresh hot chilies, seeded and coarsely chopped

I tablespoon salted black beans

2 tablespoons coarsely chopped garlic

1/4 cup coarsely chopped green onions

3 tablespoons white rice vinegar

2 tablespoons dark soy sauce

I tablespoon sugar

2 teaspoons cornstarch mixed with 2 teaspoons water

Mussels in Black Bean Sauce

Shopping List 3 pounds fresh mussels Garlic Fresh ginger Green onions

Preparation Time: 20 minutes **Cooking Time:** 8 to 12 minutes **Serves:** 4 to 6

2 tablespoons peanut oil 1/4 cup coarsely chopped salted

black beans
3 tablespoons coarsely chopped
garlic

2 tablespoons coarsely chopped peeled fresh ginger

3 pounds fresh mussels, scrubbed and debearded

2 tablespoons coarsely chopped green onions

2 teaspoons light soy sauce

M ussels are an ideal quick and easy food. Once they have been scrubbed clean in cold water and debearded, they cook very rapidly, announcing that they are done by cordially opening their shells. Make sure they are firmly closed before cooking: throw away any that do not close up when touched or that have damaged shells.

A greater quantity of this dish can easily be prepared for larger gatherings. I prefer to use smaller mussels; if you have a choice, try them.

R E C I P E

Heat a wok or large skillet, then add the oil, black beans, garlic, and ginger. Stirfry for 20 seconds and add the mussels. Continue to cook for 5 minutes, or until all the mussels have opened. Discard any that have difficulty opening or do not open at all. Add the green onions and soy sauce. Give the mixture a final stir and serve at once.

Fast Curried Fish Stew

This recipe derives from Southeast Asian cuisine, as the zesty seasonings, curry paste, and coconut milk clearly suggest. A stew usually implies long, slow cooking, the opposite of quick and easy. In the case of a fish stew, however, this need not be so, especially when such dramatic seasonings are used; the delicate flesh of the fish rapidly absorbs the flavorings and long simmering is unnecessary. The sauce in this case not only spices up the fish but also keeps it moist and succulent. The result is a quick stew that is warm, savory, and satisfying to the soul as well as pleasing to the palate, just as if it had simmered for hours. The recipe can readily be increased to serve a larger group. In any event, it can rapidly be put together as a main-course dish or as a first course for a special dinner. It can be made a few hours in advance of the meal, if you wish, and reheated. You may like to add extra vegetables such as zucchini, potatoes, or other vegetables when they are in season.

Shopping List

1½ pounds fresh fish fillets, preferably cod or haddock

½ pound carrots

½ pound fresh peas, shelled, or ¼ cup frozen peas

Preparation Time: 15 minutes Cooking Time: 12 minutes, plus 5 minutes' standing time Serves: 4 to 6

R E C I P E

Cut the fish fillets into 2-inch-square chunks. Combine them with 2 teaspoons of the salt, the pepper, and toasted sesame oil and set aside.

Peel the carrots and cut them into ½-inch cubes. If you are using fresh peas, blanch them in boiling water for 2 minutes, drain, and set aside. If you are using frozen peas, let them thaw at room temperature.

Combine the coconut milk, curry powder, the remaining $\frac{1}{2}$ teaspoon salt, and the sugar in a large pot. Bring it to a simmer, add the carrots, cover, and cook for 5 minutes, or until the carrots are tender. Add the peas and cook for another minute. Add the fish chunks, bring the stew to a boil, and simmer the mixture for a further 5 minutes. Turn off the heat and let the stew stand, covered, for 5 minutes, before serving over plain rice.

1½ pounds fresh fish fillets, preferably cod or haddock

2½ teaspoons salt

I teaspoon freshly ground white or black pepper

2 teaspoons toasted sesame oil ½ pound carrots, trimmed

1/2 pound fresh peas, shelled, or 1/4 cup frozen peas

13/4 cups canned unsweetened coconut milk

2 tablespoons curry powder or paste

2 teaspoons sugar

Five-Minute Fish Cooked on a Plate

Shopping List

1 pound fresh fish fillets, preferably salmon or tuna Fresh ginger Green onions

Preparation Time: 15 minutes **Cooking Time:** 10 minutes

Serves: 4

I pound fresh fish fillets, preferably salmon or tuna

3 cup rice wine or dry sherry

tablespoons water

tablespoon dark soy sauce

teaspoon light soy sauce

teaspoons finely chopped peeled fresh ginger

teaspoons sugar

teaspoon toasted sesame oil

teaspoon cornstarch mixed with

teaspoon water

I tablespoon peanut oil 3 tablespoons finely chopped green onions This highly unusual fish dish produces perfectly cooked fish in almost no time at all. The fish is pounded until it is thin (very easy to do), and then actually cooked on the plates which, I hasten to add, must be able to withstand heating to a high temperature! The flattened fish fillets are laid on heated, oiled plates, the heated sauce is added, and the fish cooks through in about 5 minutes. Timing and touch are important here; practice this dish a few times before you make it the feature of a dinner party.

R E C I P E

Preheat the oven to 325°. Place 4 heatproof plates in the oven and let them heat for 15 minutes.

Meanwhile, divide the fish fillets into 4 portions. Place each one between sheets of plastic wrap and pound gently with a wooden mallet or rolling pin until the thickness of the fish is reduced to $\frac{1}{12}$ inch.

In a small saucepan, bring the rice wine, water, soy sauces, ginger, sugar, and toasted sesame oil to a simmer. Thicken with the cornstarch mixture.

Carefully remove the plates from the oven (they should be very hot). Brush each plate with a little peanut oil. Place a piece of fish on each plate. Pour some sauce over the top of each piece of fish, sprinkle with the green onions, and leave to stand for 5 minutes to cook through and cool slightly before serving.

Quick Pan-fried Spicy Fish

n the way home from work, my widowed mother would often pick up a small whole fish or some fillets and quickly put together this nutritious meal. With stir-fried vegetables, yesterday's rice reheated, and perhaps the Western touch of a salad, you have a quick, wholesome, and satisfying meal. This fish also goes wonderfully well with pasta. For a more elegant meal try substituting fresh raw prawns for the fish.

R E C I P E

Rub the fish fillets with the five-spice powder and salt. Heat a wok or large skillet until it is hot, then add the oil. Gently pan-fry the fish on each side until it is lightly browned and remove with a spatula. To the remaining oil add the garlic, ginger, rice wine, soy sauce, and toasted sesame oil. Return the fish to the wok and gently reheat. Serve at once.

Shopping List

1 pound fresh fish fillets, preferably cod or haddock Garlic Fresh ginger

Preparation Time: 10 minutes Cooking Time: 10 minutes

Serves: 4

I pound fresh fish fillets, preferably cod or haddock

I teaspoon five-spice powder

I teaspoon salt

1 1/2 tablespoons peanut oil

2 tablespoons coarsely chopped garlic

2 tablespoons coarsely chopped peeled fresh ginger

1 ½ tablespoons rice wine or dry sherry

2 teaspoons light soy sauce

2 teaspoons toasted sesame oil

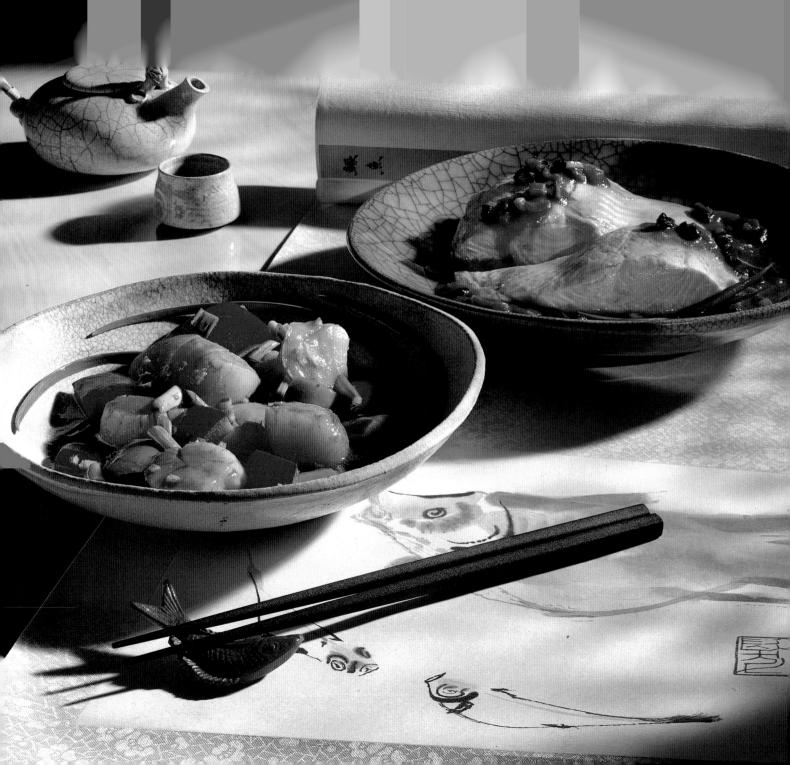

Steamed Salmon with Black Bean Sauce

Stir-fried Peppers with Scallops Page 48

Steamed Salmon with Black Bean Sauce

Fresh salmon is a luxury, but every serious diner deserves it once in a while. Buy it in season, when it is least expensive. Prepare it using this Chinese steaming method; it preserves all the noble characteristics of the salmon. Here, I use a traditional black bean sauce. It has a very pleasantly pungent taste that enhances the distinctive salmon flavor, making a wonderful contrast on the palate. Haddock or cod fillets make a successful substitute for salmon, or you could even try scallops. This simple dish would grace a dinner party as a main course or as a brilliant first course.

R E C I P E

Set a rack into a wok or deep pan. Add in water to a depth of $2\frac{1}{2}$ inches and bring it to a simmer.

Rub the salmon fillets with the salt and toasted sesame oil and place on a heatproof plate that will fit into the wok or pan. Place the plate holding the fish on the rack, cover tightly and steam for about 6 minutes. It is best to undercook the salmon slightly, as it will continue to cook even after it has been removed from the steamer.

While the salmon is steaming, heat a wok or large skillet, then add the oil, black beans, garlic, and ginger. Stir-fry the mixture for 1 minute, then add the green onions, soy sauces, and water and simmer for 1 minute. Add the cornstarch mixture and stir the sauce until it thickens.

When the salmon is cooked, pour the hot sauce over the salmon and serve at once.

Shopping List

1 pound fresh salmon fillets, sliced 1 inch thick Garlic Green onions Fresh ginger

Preparation Time: 10 minutes Cooking Time: 10 minutes

Serves: 4 to 6

- I pound fresh salmon fillets, sliced I inch thick
- I teaspoon salt
- 2 teaspoons toasted sesame oil

Sauce

- I tablespoon peanut oil
- 2 tablespoons coarsely chopped salted black beans
- 1 ½ tablespoons coarsely chopped garlic
- I tablespoon finely chopped peeled fresh ginger
- 3 tablespoons coarsely chopped green onions
- I tablespoon dark soy sauce
- 2 teaspoons light soy sauce
- ²/₃ cup water
- I teaspoon cornstarch mixed with I teaspoon water

Ten-Minute Poached Salmon with Green Onion Sauce

Shopping List
1 pound fresh salmon fillets
Green onions
Fresh ginger

Preparation Time: 12 minutes
Cooking Time: 6 to 7 minutes, plus
8 minutes' standing time
Serves: 4

I pound fresh salmon fillets
2 teaspoons salt
½ teaspoon freshly ground white or
black pepper
2½ cups water
6 tablespoons coarsely chopped
green onions
I tablespoon finely chopped peeled
fresh ginger
I½ tablespoons peanut oil

2 teaspoons toasted sesame oil

Splendid salmon: a favorite with everyone, its noble character lends itself to countless recipes and sauces, but I enjoy it most prepared in a simple and almost unadorned fashion, as in this recipe. The Chinese style is to consume fish neither raw nor overcooked. The aim is to capture the natural flavor, moistness, and texture of the fish. The technique of poaching manages this admirably.

This is truly a quick and elegant dish. Serve it as a main course for the family (accompanied with an easy vegetable dish and rice) when salmon is in season, or as a first or main course for a special dinner party. Sea bass or sole fillets may be substituted for the salmon if you wish.

R E C I P E

Rub the salmon fillets with I teaspoon of the salt and the pepper. Place the water in a skillet and bring to a simmer. Add the salmon, simmer for 2 to 3 minutes, cover tightly, and turn off the heat. Let sit for 8 minutes.

Combine the green onions, ginger, and the remaining I teaspoon salt together in a small bowl. In a small pan, combine the peanut oil and toasted sesame oil and bring it to the smoking point.

Remove the salmon from the water and arrange on a platter. Scatter the green onion mixture on top and pour the hot oil over it. Serve at once.

Fried Fish with Whole Garlic

overs of the "stinking rose"—and who is not?—understand that whole garlic cloves are among the most delicious and sweetly pungent foods in the world. Garlic adds great dimension to so many different dishes, and to fish in particular. In Shanghai a dish featuring eels and whole garlic is very popular. I have adapted the recipe to use commonly available fish fillets; these work as well and are easy to prepare. If you prefer, you can also substitute whole shallots or small onions for the garlic. Serve this dish with rice and stir-fried vegetables for a healthy and very tasty meal.

Shopping List

1 pound fresh fish fillets, preferably cod or haddock Garlic Fresh ginger

Preparation Time: 15 minutes Cooking Time: 10 minutes Serves: 4

R E C I P E

Rub the fish fillets with salt and cornstarch. Heat a wok or large skillet, then add the oil. Fry the fish on both sides until it is golden brown. Remove the fish and drain on paper towels.

Drain all but I tablespoon of oil from the pan, add the garlic and ginger, and stir-fry for 20 seconds. Then add the sauce ingredients and cook for 3 minutes, or until the garlic is tender. Return the fish to the wok and reheat it. Serve at once, with the garlic cloves.

- I pound fresh fish fillets, preferably cod or haddock
- I teaspoon salt
- 3 tablespoons cornstarch
- 1/4 cup peanut oil
- 8 garlic cloves, peeled
- 2 tablespoons coarsely chopped peeled fresh ginger

Sauce

- I tablespoon rice wine or dry sherry
- 3 tablespoons water
- I tablespoon light soy sauce
- I tablespoon yellow bean sauce
- I teaspoon sugar
- I tablespoon dark soy sauce

Rice Wine-steeped Fish

Shopping List

1 pound fresh fish fillets, preferably cod or haddock Green onions

Preparation Time: 8 minutes Cooking Time: 12 minutes, plus 5 minutes' standing time

Serves: 4

2 cups rice wine or dry sherry
⅓3 cup water
2 tablespoons light soy sauce
I teaspoon freshly ground white pepper
2 teaspoons salt
2 teaspoons sugar
2 teaspoons cornstarch mixed with
2 teaspoons cold water
I pound fresh fish fillets, preferably

cod or haddock
teaspoons toasted sesame oil
tablespoons finely chopped
green onions

Fish and rice wine go together like love and marriage—maybe better, because they always marry well. The distinct rich wine flavor enhances the fish taste without drowning it; it works much like butter and lemon in certain Western recipes. Once the alcohol has evaporated in the steeping process, there remains the subtle residual rice wine aroma. After the preparation of the sauce, the dish is rapidly completed, producing a simple but elegant meal that is tasty and wholesome. It may be served at a party or at an informal meal for family and friends. The dish reheats well provided this is done gently.

R E C I P E

Bring the rice wine, water, soy sauce, pepper, I teaspoon of the salt, and the sugar to the boil in a skillet. Reduce the liquid over high heat to about half its original volume, add the cornstarch mixture, and cook for 30 seconds.

While the sauce is reducing, rub the fish fillets with the remaining I teaspoon salt and the toasted sesame oil and set aside.

Add the fish fillets to the liquid and simmer gently for 2 minutes. Take it off the heat and let sit for another 5 minutes.

Transfer the fish fillets to a serving platter, pour the sauce over them, and sprinkle with the green onions.

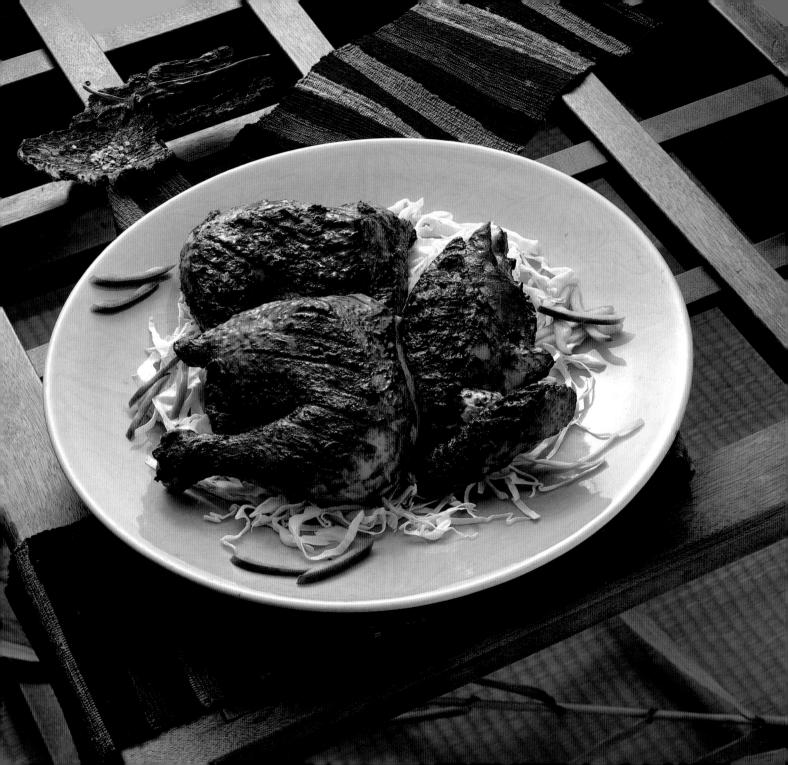

hicken, duck, squab, pheasant, and quail: fowl in its many forms has been central to the Chinese cuisine for millennia. And the Chinese, in my opinion, are the world's experts in cooking fowl. All parts of each bird are used and, after cooking has transformed them, prized: the wings, the entrails, even the feet!

In the West we do not have such a wide variety of fowl so easily available, and many of the game birds require extensive preparation not appropriate to the quick and easy approach. Thus, here I stay with what I have elsewhere called "the sweet bird of our youth"—chicken. Of all fowl it is the most accessible and adaptable. It is relatively inexpensive, easy to cook, and goes well with almost every other food. With its own delicate taste and great receptivity to other flavors, it lends itself to many recipes. Here I use parts of the chicken that are easy to cook, such as breasts and wings. Where longer cooking is required or expedient, I use chicken thighs. I have also included a few turkey recipes here—turkey is another nutritious and versatile food that deserves a bigger place in our diet.

- I. Ouick Chinese Chicken Salad
- 2. Quick Orange-Lemon Chicken
- 3. Sterling's Stir-fried Chicken with Kiwi
- 4. Crispy Chicken in Garlic-Ginger Sauce
- 5. Spicy Hot Chicken with Basil
- 6. Baked Curried Chicken Thighs
- 7. Braised Chicken and Mushroom Casserole
- 8. Red-cooked Chicken Wings
- 9. Chicken Thigh Casserole with Orange
- Stir-fried Smoked Chicken with Napa Cabbage
- 11. Chinese Barbecued Chicken
- 12. Stir-fried Chicken Livers with Onions
- 13. Ground Turkey Patties
- 14. Stir-fried Turkey with Peppers

Shopping List

3/4 pound chicken breasts Garlic Fresh ginger Green onions

Preparation Time: 25 minutes **Cooking Time:** 8 minutes plus 10 minutes' standing time

Serves: 2 to 4

3/4 pound chicken breasts 2 teaspoons salt

Sauce

- I garlic clove, peeled
- I slice fresh peeled ginger
- 2 green onions, green tops removed
- 2 teaspoons chili bean paste
- 2 teaspoons dark soy sauce
- I teaspoon sugar
- 2 teaspoons white rice vinegar
- 2 teaspoons sesame paste or peanut butter
- ½ teaspoon salt
- 1/2 teaspoon freshly ground black pepper
- 2 teaspoons toasted sesame oil
- 1/2 pound iceberg lettuce, finely shredded
- 2 tablespoons white rice vinegar

ost of the work for this dish can be done well in advance, so that when it is time to eat you have a true quick and easy treat. Once the sauce is made and the chicken cooked, you are a few minutes from enjoying a delightful chicken salad. This is an ideal recipe for entertaining or for a light luncheon.

R E C I P E

Remove the skin from the chicken breasts and place the chicken in a pot. Pour in enough cold water to cover the chicken and add the salt. Bring the mixture to a simmer and cook for 5 minutes. Turn off the heat and cover tightly. Leave the chicken to stand in the hot water for 10 minutes.

Meanwhile, put all the sauce ingredients into a blender and blend well. Toss the lettuce with the white rice vinegar and place on a serving platter.

Remove the chicken from its cooking liquid and allow to cool. Pull the meat off the bone, shred it, and toss it with the sauce. Place the chicken and the sauce on top of the lettuce and serve at once.

Quick Orange-Lemon Chicken

Shopping List

3/4 pound boneless chicken breasts 1 orange 2 lemons Garlic Fresh ginger Green onions

Preparation Time: 15 minutes **Cooking Time:** 5 minutes

Serves: 2

³/₄ pound boneless chicken breasts

I tablespoon peanut oil

2 tablespoons coarsely chopped garlic

I teaspoon finely chopped peeled fresh ginger

2 teaspoons finely chopped orange zest

2 teaspoons finely chopped lemon zest

1/4 cup orange juice

1/4 cup fresh lemon juice

I tablespoon light soy sauce

I tablespoon sugar

I teaspoon cornstarch mixed with I teaspoon water

I teaspoon chili bean paste

2 teaspoons toasted sesame oil

3 tablespoons coarsely chopped green onions

range and lemon are wonderful flavors that chicken breasts readily absorb and blend with. This is a classic quick and easy meal, quite satisfying as a main course with plain rice and a salad. Alternatively, serve it at room temperature as part of a cold buffet or as exotic picnic fare.

R E C I P E

Remove the skin from the chicken and cut the meat into long strips. Blanch the chicken for 30 seconds in a pan of boiling salted water. Drain and set aside.

Heat a wok or large skillet, then add the oil, garlic, and ginger. Stir-fry the mixture for 10 seconds and add the rest of the ingredients except for the chicken. Bring the mixture to a simmer, add the chicken to the wok, and cook through. Remember that the chicken will continue to cook for at least 30 seconds after you have removed it from the wok, so be sure not to overcook it. Serve at once.

Sterling's Stir-fried Chicken with Kiwi

Sterling Doughty of Geneva, Switzerland, is an avid admirer of Chinese cooking. He shares his thoughts on cooking and his recipes—including this one—with me. I immediately saw that it fits into the quick and easy category. The kiwi fruit, becoming less and less exotic to us, needs very little cooking and blends nicely with the delicate chicken breast flavor. Try substituting mango or papaya for the kiwi fruit sometimes—either one makes a nice alternative.

Shopping List
1 pound boneless chicken breasts
2 kiwi fruit
Garlic

Preparation Time: 10 minutes **Cooking Time:** 4 minutes **Serves:** 4 to 6

R E C I P E

Cut the chicken into $\frac{1}{2}$ -inch cubes. Combine the chicken with the salt and cornstarch.

Heat a wok or large skillet, then add the oil and garlic. Stir-fry for 10 seconds and add the chicken. Stir-fry for 2 minutes, then add the chilli bean paste, sugar, and kiwi fruit. Stir and mix for 1 minute. Finally, add the toasted sesame oil and give the mixture one good stir. Serve at once.

- I pound boneless chicken breasts
- I teaspoon salt
- I teaspoon cornstarch
- I tablespoon peanut oil
- 2 tablespoons coarsely chopped garlic
- I teaspoon chili bean paste
- I teaspoon sugar
- 2 kiwi fruit, peeled and quartered
- I teaspoon toasted sesame oil

Poultry 69

Crispy Chicken in Garlic-Ginger Sauce

Shopping List

1½ pounds chicken thighs Green onions Garlic Fresh ginger

Preparation Time: 20 minutes Cooking Time: 7 minutes

Serves: 4 to 6

11/2 pounds chicken thighs

2 tablespoons light soy sauce

2 tablespoons rice wine or dry sherry

3 tablespoons coarsely chopped green onions

2 tablespoons coarsely chopped garlic

I tablespoon coarsely chopped peeled fresh ginger

Sauce

I tablespoon light soy sauce

I tablespoon sugar

I tablespoon white rice vinegar

2 teaspoons toasted sesame oil

2 cups peanut oil Cornstarch for dusting Here is a dish that is quick and easy and still combines most of the qualities that make Chinese food so appealing: contrasting tastes and textures; a dipping sauce; a crisp exterior and tender interior; lightness and the ability to satisfy at the same time. Most of the work is in the preparation, with a few minutes of cooking time—in fact, you can prepare the chicken and sauce several hours before you are ready to cook. Serve this as a main course with rice and a simple salad.

R E C I P E

Remove the bones from the chicken thighs by running a knife through to the bone on each side, then cutting out the bone. Remove the skin and cut the chicken into 1-inch chunks. Combine the chicken with the soy sauce and rice wine.

Combine the green onions, garlic, and ginger in one bowl and combine the sauce ingredients in another.

Heat a wok or large skillet, then add the 2 cups peanut oil. Dust the chicken pieces with the cornstarch and deep-fry for 5 minutes, or until golden brown. Remove from the wok and drain on paper towels, then place on a serving platter and keep warm. Drain all the oil from the wok and reheat the wok. Add the green onions, garlic, and ginger, and stir-fry for 20 seconds. Pour in the sauce ingredients and cook for a further 20 seconds. Serve the chicken with the sauce on the side.

Spicy Hot Chicken with Basil

This is a savory, almost lusty chicken dish of Southeast Asian provenance. Chicken thighs, with their darker, firmer meat, lend themselves to marinades and longer cooking. I enjoy their more robust flavor and more substantial texture. Chicken combines nicely with all spices, but I particularly enjoy the surprise here of the anise-flavored basil, which is so nice a counterpoint to the other spices. If basil is unavailable, you can substitute fresh mint. Serve the dish with plain rice and a salad or green vegetable for a complete meal. It can be made in advance and stored in the refrigerator, as it reheats well.

Shopping List 2 pounds chicken thighs Garlic Fresh basil

Preparation Time: 25 minutes Cooking Time: 10 minutes

Serves: 4

R E C I P E

Remove the bones from the chicken thighs by running a knife through to the bone on each side, then cutting out the bone. Remove the skin and cut the chicken into 1-inch chunks, then combine it in a bowl with the light soy sauce, cornstarch, and toasted sesame oil.

Heat a wok or large skillet and add the oil. When the oil is hot, add the chicken. Stir-fry for 5 minutes, then remove the chicken and drain off the oil. Return the drained chicken to the wok and add all the remaining ingredients except the basil leaves. Cook for another 5 minutes, stirring from time to time. When the chicken is cooked, add the basil and stir well. Transfer to a serving platter and serve at once.

- 2 pounds chicken thighs 2 teaspoons light soy sauce
- 2 teaspoons cornstarch
- I teaspoon toasted sesame oil
- 1½ tablespoons peanut oil
- 2 tablespoons coarsely chopped garlic
- 2 teaspoons chili bean paste
- 2 teaspoons hoisin sauce
- 2 teaspoons oyster sauce
- I teaspoon dark soy sauce
- I teaspoon sugar

Large handful fresh basil leaves

Poultry 71

Baked Curried Chicken Thighs

Shopping List 2 pounds chicken thighs Fresh ginger Garlic

Preparation Time: 10 minutes **Cooking Time:** 35 minutes **Serves:** 4

2 pounds chicken thighs

Curry Sauce

- 2 tablespoons curry powder or paste
- I tablespoon light soy sauce
- I tablespoon finely chopped garlic
- I tablespoon chopped peeled fresh ginger
- I tablespoon rice wine or dry sherry
- 2 teaspoons sugar I teaspoon salt
- I teaspoon toasted sesame oil

Jurry is a popular seasoning in South China; baking, however, is a rarely used technique—ovens are found only in commercial bakeries. This is a pity for the Chinese, because baking is a very convenient method of cooking: you can place everything in the dish and into the oven and go off to do other things while the meal looks after itself. In China, this would be a clay-pot meal. Here I have combined simple but dramatic flavors to create an unusual curry dish. With rice and a vegetable or salad, it makes a complete and sustaining meal that takes less than 1 hour to prepare. To make an even more substantial meal, bake ½ pound finely diced and blanched potatoes and carrots along with the chicken. You can substitute chicken breasts for the thighs, but remember that they will take only about 15 minutes to cook.

R E C I P E

Preheat the oven to 475°. Remove the skin from the thighs. Place the thighs in a roasting pan or ovenproof dish. Combine all the sauce ingredients, add to the chicken, and mix thoroughly, making sure that the thighs are completely coated.

Bake the thighs for 15 minutes. Turn them over and continue to cook for another 15 to 20 minutes, depending on how well-done you like your chicken. Serve at once.

Braised Chicken and Mushroom Casserole

Yes, clearly this takes a bit longer than the average quick and easy meal, but it is one of my mother's favorites and it is deliced. on winter mornings before she left for work, placing it with rice on the heater to keep warm so I could eat it for lunch. It is a savory dish that reheats well and is worth the extra time and effort. The chicken thighs are robust enough to take the longer cooking and the seasonings.

½ pound yellow onions Garlic

1½ pounds chicken thighs

Fresh ginger

Shopping List

Preparation Time: 23 minutes Cooking Time: 11 minutes

Serves: 4 to 6

R E C I P E

Soak the dried mushrooms in the warm water for 20 minutes, or until soft. While the mushrooms are soaking, remove the skin and bones from the chicken thighs. Cut the flesh into 1-inch cubes.

Squeeze the excess liquid from the mushrooms and remove and discard the stalks. Cut the caps into quarters. Save the soaking liquid.

Heat a wok or large skillet, then add the oil and chicken. Stir-fry for 31/2 minutes, or until the chicken begins to brown. Pour off any excess fat and reheat the wok. Add the onions, garlic, ginger, and mushrooms and stir-fry for 2 minutes. Then add 3 cup of the liquid in which the mushrooms were soaked, the rice wine, and oyster sauce. Continue cooking over high heat for 5 minutes. Serve at once.

I ounce Chinese dried mushrooms 3³/₄ cups warm water 1½ pounds chicken thighs I tablespoon peanut oil 1/2 pound yellow onions, sliced

2 tablespoons coarsely chopped garlic

I tablespoon coarsely chopped peeled fresh ginger

2 tablespoons rice wine or dry sherry 1/4 cup oyster sauce

73 Poultry

Red-cooked Chicken Wings

Shopping List

1½ pounds chicken wings Fresh ginger Garlic

Preparation Time: 14 minutes Cooking Time: 15 minutes Serves: 4 to 6

I ½ pounds chicken wings
I tablespoon peanut oil
I tablespoon coarsely chopped peeled fresh ginger
I tablespoon coarsely chopped garlic
½ teaspoon salt
2 tablespoons dark soy sauce
I tablespoon rice wine or dry sherry
3 tablespoons hoisin sauce
2 teaspoons sugar
2 teaspoons chili bean paste
¾3 cup water

Red-cooking" simply means simmering in a richly flavored sauce that also imparts a deep red color to the food. Here I use chicken wings, the tastiest and most underrated part of the chicken, and the result is a tempting dish, quick to make and nicely reheatable, taking only about 30 minutes. You can use chicken thighs and drumsticks instead of wings if you wish, but they will need a slightly longer cooking time.

R E C I P E

Cut the chicken wings in half at the joint. Heat a wok or large skillet, then add the oil, ginger, garlic, and salt. Stir-fry the mixture for 10 seconds. Add the rest of the ingredients except for the wings and simmer for 1 minute. Put in the wings, cover the wok, and cook for 15 minutes, or until the wings are cooked through. Serve at once or let cool and serve at room temperature.

Chicken Thigh Casserole with Orange

This is an "overnighter." My mother used to make it the night before and simply reheat it at dinner time. She used dried orange peels but I like the clean taste of fresh oranges. The easiest way to remove the orange zest is with a vegetable peeler. Then pile the resulting pieces of zest on top of each other and cut into thin strips with a sharp knife.

Prepare this dish the day before you need it, when you have some time, then just reheat this rich and delicious treat—a perfect meal for a cold winter's eve.

Shopping List
2 pounds chicken thighs
2 oranges
Fresh ginger
Garlic

Preparation Time: 20 minutes Cooking Time: 24 minutes

Serves: 4

R E C I P E

Remove the skins from the chicken thighs. Heat a large, heavy, flameproof casserole, then add the oil. Quickly brown the chicken thighs on both sides. Push the thighs to the side of the casserole, then add the garlic, ginger, black beans, and orange zest. Stir for 30 seconds. Then add the orange juice, soy sauce, and chili bean paste. Bring the mixture to a boil, then lower the heat to a simmer. Cover the casserole tightly and continue to cook for about 20 minutes. Serve at once.

2 pounds chicken thighs
1 ½ tablespoons peanut oil
1 tablespoon finely chopped garlic
1 tablespoon finely chopped peeled fresh ginger
2 tablespoon salted black beans
2 teaspoons orange zest strips
¾ cup orange juice
2 tablespoons light soy sauce
2 teaspoons chili bean paste

Poultry 75

Stir-fried Smoked Chicken with Napa Cabbage

Chinese Lamb Curry Page 98

Stir-fried Smoked Chicken with Napa Cabbage

Shopping List

1½ pounds smoked chicken 1 pound Napa cabbage Garlic Fresh ginger

Preparation Time: 15 minutes Cooking Time: 8 minutes Serves: 4 to 6

1½ pounds smoked chicken
1 pound Napa cabbage, trimmed
1½ tablespoons peanut oil
3 tablespoons coarsely chopped garlic
1 tablespoon coarsely chopped peeled fresh ginger
1 tablespoon dark soy sauce
1 tablespoon rice wine or dry sherry

Smoked chicken and duck are very popular in China. Such delicacies require the time-consuming process of smoking that, fortunately, is done for us. Smoked chicken and duck are readily available in supermarkets and specialty food shops. Thus we can turn a complex recipe into something quick and easy, as in this dish, a northern Chinese favorite, easy to make and very pleasing to the eye and the palate. Zucchini, snow peas, peppers, or carrots may be used instead of Napa cabbage. With rice and a salad, this makes a substantial and nutritious meal.

R E C I P E

With your fingers, tear the meat from the bones of the chicken. Cut it into large shreds and set aside. Discard the bones. Coarsely chop the Napa cabbage.

Heat a wok or large skillet, then add the oil, garlic, and ginger. Stir-fry the mixture for 10 seconds and add the Napa cabbage. Continue to stir-fry for 5 minutes, add the soy sauce and rice wine, and cook another minute. Then add the smoked chicken and cook through. Serve at once.

Chinese Barbecued Chicken

Shopping List

1 whole chicken, about 3 to 3½ pounds Garlic Fresh ginger

Preparation Time: 10 minutes, plus 1 hour for marinating Cooking Time: 25 minutes

Serves: 4

I whole chicken, about 3 to 3½ pounds 2 teaspoons salt

Marinade

4 garlic cloves, peeled 2 slices fresh peeled ginger

5 tablespoons hoisin sauce

3 tablespoons rice wine or dry sherry

I tablespoon dark soy sauce

I tablespoon light soy sauce

I teaspoon chili bean paste

2 teaspoons sugar

2 teaspoons toasted sesame oil

Then warm weather calls you out of doors, it is appropriate to enjoy cooking and eating outside. Summer is the time for grilling, and this recipe calls for the outdoor grill, although you can, of course, cook it indoors under your broiler. Chinese seasonings and spices add new dimensions to any grilled food, and with this recipe most of the work can be done well in advance. The cooking time is a short 25 minutes, during which you can prepare the salad or a stirfried vegetable dish and perhaps some rice to accompany the chicken. The quantities given below can easily be doubled to feed a larger crowd, and the chicken makes wonderfully exotic picnic fare if served cold.

R E C I P E

Cut the chicken into quarters and rub each piece evenly with the salt. Combine the rest of the ingredients in a blender and puree them. Rub this mixture over the chicken and set aside to marinate for at least I hour at room temperature, or cover with plastic wrap and marinate overnight in the refrigerator. To speed up the cooking process, bring the marinated chicken to room temperature before cooking.

Preheat the broiler or light a fire in an open grill. When the broiler is hot or the coals are covered with gray ash, cook the chicken leg quarters for 15 minutes, turning them to make sure that they do not burn. Then add the breast quarters and continue cooking for 10 more minutes, turning them to make sure they cook evenly. Serve hot or allow to cool and serve at room temperature.

Stir-fried Chicken Livers with Onions

Chicken livers are among the easiest foods to prepare. The trick is to combine them with the proper seasonings and spices so that their delicateness is retained while they are given a new dimension—hence the onions and the five-spice powder in this recipe. Serve this dish as part of a Chinese meal or as a main course with rice and a vegetable. Calf's liver may be substituted for the chicken livers if you wish.

Shopping List
1 pound chicken livers
2 vellow onions

Preparation Time: 14 minutes Cooking Time: 11 minutes Serves: 2 to 4

R E C I P E

Cut the chicken livers into bite-sized pieces. Combine the livers with I tablespoon of the rice wine, the soy sauce, five-spice powder, $\frac{1}{2}$ teaspoon of the salt, the pepper, and cornstarch. Mix well.

Heat a wok or large skillet, then add 2 teaspoons of the peanut oil. Stir-fry the livers for about 4 minutes, or until they are brown on the outside but still pink inside. Remove the livers from the wok. Wipe the wok clean, then reheat. Add the remaining I tablespoon peanut oil, the remaining 1/2 teaspoon salt, and the onions. Stir-fry for 4 minutes, or until the onions are brown and slightly caramelized. Return the livers to the wok and add the remaining 2 teaspoons rice wine and the toasted sesame oil. Stir-fry for 2 more minutes. Serve at once.

I pound chicken livers
I tablespoon plus 2 teaspoons rice wine or dry sherry
I tablespoon light soy sauce
½ teaspoon five-spice powder
I teaspoon salt
¼ teaspoon freshly ground black pepper
I tablespoon cornstarch
I tablespoon plus 2 teaspoons peanut oil
2 yellow onions, sliced
2 teaspoons toasted sesame oil

Poultry 79

Ground Turkey Patties

Shopping List

1 pound boneless turkey breast 1 egg Fresh ginger Green onions Cilantro Garlic

Preparation Time: 22 minutes Cooking Time: 6 minutes

Serves: 4

I pound boneless turkey breast, skinned

I teaspoon salt

½ teaspoon freshly ground white or black pepper

2 tablespoons coarsely chopped garlic

I tablespoon coarsely chopped peeled fresh ginger

1/4 cup finely chopped green onions

3 tablespoons finely chopped fresh cilantro

I tablespoon cornstarch

I egg white

3 tablespoons peanut oil

Sauce

- 2 tablespoons rice wine or dry sherry
- 2 tablespoons water
- 3 tablespoons oyster sauce

In China, turkey is virtually unknown. I believe that the Chinese palate would find turkey breast rather bland and tasteless, lacking the grace and delicateness of chicken. But I think turkey is a versatile food that needs only a little care and imaginative seasonings to make it quite delectable. Turkey breast is also ideal for quick cooking. The preparation of this dish takes a little time, but the spices and seasonings do enliven the turkey and the actual cooking time is quite short. You can, if you wish, make the patties several hours in advance and leave them, covered with plastic wrap, in the refrigerator until you are ready to cook them. The patties make an excellent appetizer.

R E C I P E

Coarsely chop the turkey breast meat in a food processor or by hand. If you chop it in a food processor, be sure to use the pulse so that the flesh is not overprocessed; it should have the texture of ground beef. Mix in the salt, pepper, garlic, ginger, green onions, cilantro, cornstarch, and egg white. Form the mixture into small round patties about 3 inches in diameter.

Heat a wok or large skillet, then add the oil. Fry the patties for about 2 minutes on each side, or until they are nicely browned. Drain them on paper towels. Pour off the fat from the wok. Combine and pour in the sauce ingredients. Bring to a simmer and return the patties to the wok to warm through in the sauce. Serve at once.

Stir-fried Turkey with Peppers

Here again, I substitute nutritious, low-fat turkey meat for chicken, and it works wonderfully as a stir-fried meal. The red peppers add spice and color to this wholesome and inexpensive dish, though you can successfully substitute green peppers or even zucchini.

Shopping List

1 pound boneless turkey breast 1 pound red bell peppers

Preparation Time: 10 minutes **Cooking Time:** 4 to 5 minutes **Serves:** 2 to 4

R E C I P E

Cut the turkey breast meat into 3-by- $\frac{1}{2}$ -inch slices. Combine with the marinade ingredients in a medium-sized bowl and leave to stand for 5 minutes. Core and seed the red peppers and cut them into $\frac{1}{2}$ -inch-wide strips. Set aside.

Heat a wok or large skillet, then add the oil. Add the turkey and stir-fry for 10 seconds. Then add the pepper strips and stir-fry another 10 seconds. Finally add the rice wine, salt, and oyster sauce and continue to stir-fry for 2 to 3 minutes. Remember that the turkey will continue to cook for a short time after it is removed from the wok, so undercook rather than overcook it. Serve at once.

I pound boneless turkey breast, skinned

Marinade

 I ½ tablespoons light soy sauce
 I tablespoon rice wine or dry sherry
 teaspoons toasted sesame oil

teaspoons cornstarch

2 teaspoons cornstarch

I pound red bell peppers
I ½ tablespoons peanut oil
2 tablespoons rice wine or
dry sherry
½ teaspoon salt
I tablespoon oyster sauce

Poultry 81

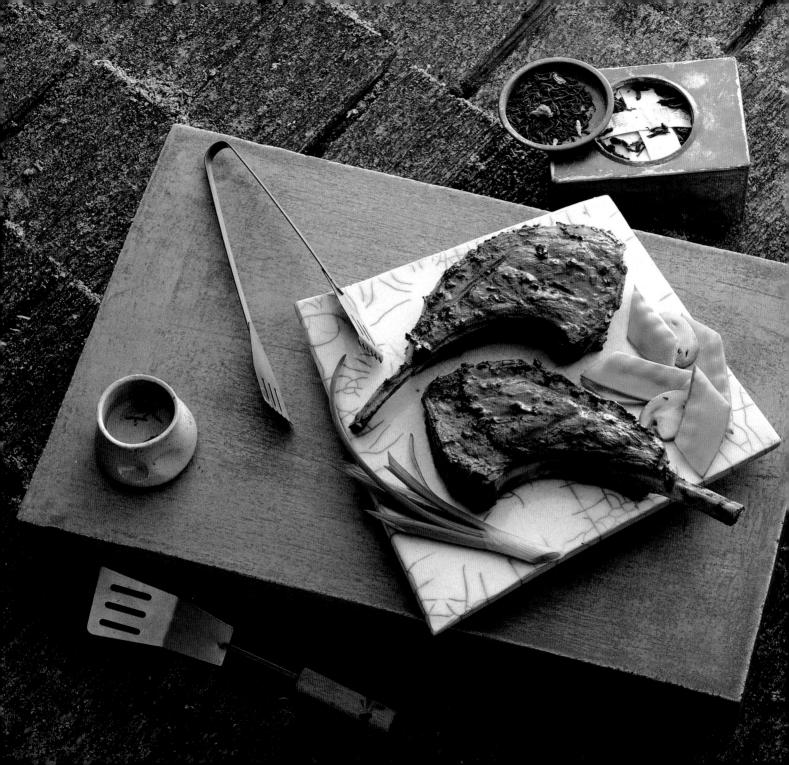

Grilled Lamb Chops with Chinese Marinade Page 100

Meat is a very popular food in China, but it is not consumed in such quantities as in the West. It is rarely the central dish in any meal; rather, it is used to accompany and to complement other foods—vegetables and rice, for example—or in sauces and soups. This makes for a very healthy diet: in the West we use too much animal protein, at the cost of the vegetable nutrients and food fiber our bodies require.

The Chinese prepare meat in a number of basic ways: steaming, stir-frying, braising, and frying are the techniques most often used. Meat is almost always cut into small pieces or thin slices. This makes for minimum cooking and maximum retention of natural flavors and juices. "Quick and easy" is the general rule in China for the preparation of meat.

The recipes here may be offered as main courses. In some cases, which I note, the dishes can be made well ahead of time and reheated when needed. All of them are delectable, and none is too complicated. I indicate which ones go well with rice and thus quite naturally can be part of a one-dish meal, with perhaps a favorite salad.

- I. Beef with Ginger and Pineapple
- 2. Tomato Beef with Onions
- 3. Mango Beef
- 4. Spicy Szechwan-style Beef
- 5. Fast Spicy Meat Sauce for Noodles
- 6. Fifteen-Minute Steak
- 7. Stir-fried Beef with Onions and Mint
- 8. Stir-fried Pork with Pineapple
- 9. Stir-fried Pork with Lichees
- 10. Marinated Broiled Pork Chops
- Custard with Ground Pork, Green Onions, and Oyster Sauce
- 12. Do-ahead Reheatable Black Bean Spareribs
- 13. Barbecued Chinese Spareribs
- 14. Chinese Lamb Curry
- 15. Hot and Tangy Ground Lamb
- Grilled Lamb Chops with Chinese Marinade
- 17. Do-ahead Reheatable Lamb Stew

Beef with Ginger and Pineapple

Shopping List

1 pound lean market or New York steak ½ pound fresh pineapple 2 red bell peppers Fresh ginger Green onions

Preparation Time: 21 minutes Cooking Time: 8 minutes Serves: 4 to 6

I pound lean market or New York steak

I teaspoon salt

4 teaspoons rice wine or dry sherry

4 teaspoons toasted sesame oil

1½ teaspoons cornstarch ½ pound fresh pineapple

2 red bell peppers

2 green onions

2 tablespoons peanut oil

2 tablespoons shredded peeled fresh ginger

I tablespoon water

I teaspoon light soy sauce

This recipe is derived from a dish that I enjoyed at Lai Ching Heen, the marvelous Chinese restaurant in Hong Kong's Regent Hotel. I regard it as exemplary of the innovative new Hong Kong cuisine, in which new ingredients and techniques are being employed to transform traditional recipes. A mouthwatering combination of tastes and textures, it is remarkably easy to prepare and is most appropriate for a dinner party or any special meal. You can, if you wish, prepare the meat, vegetables, and fruit in advance and store them, well wrapped, in the refrigerator until you are ready to cook.

R E C I P E

Cut the beef into 2-by-1/4-inch slices and put them into a bowl. Add the salt, 2 teaspoons of the rice wine, 2 teaspoons of the toasted sesame oil, and the cornstarch and mix well.

Peel and cut the pineapple into thick slices, discarding the tough core. Core and seed the peppers and cut them into wedges. Cut the green onions into 3-inch lengths.

Heat a wok or large skillet, then pour in the oil. Add the beef and stir-fry for I minute to brown. Remove the beef with a slotted spoon and set aside. Add the ginger, peppers, and green onions to the wok and stir-fry for I minute. Pour in the water, the remaining 2 teaspoons rice wine, and the soy sauce and cook for 3 minutes. Drain the juices from the beef, and add this to the wok. Return the beef to the wok, add the pineapple, and cook until they are heated through. Add the remaining 2 teaspoons toasted sesame oil and give the mixture one or two final stirs. Serve at once.

Tomato Beef with **Onions**

I learned to make this quick and easy dish in my uncle's restaurant. I still make it when tomatoes are in season. It is a wonderful combination of two good foods, bound together by the richness of the seasonings and the oyster sauce. Serve it over egg noodles or plain rice.

Shopping List

1 pound lean market or New York steak1 pound fresh tomatoes½ pound yellow onions

Preparation Time: 15 minutes Cooking Time: 10 minutes Serves: 4 to 6

R E C I P E

Cut the beef into 2-by-1/4-inch slices and put them into a bowl. Add the soy sauce, rice wine, and cornstarch and mix well. Peel the onions and cut into thick slices. Quarter the tomatoes.

Heat a wok or large skillet, then pour in the oil. Add the beef and stir-fry for 2 minutes to brown. Remove the beef with a slotted spoon. Add the onions to the wok and stir-fry for 1 minute. Pour in the water and cook for 3 minutes. Drain the juices from the beef and add this to the wok. Continue to cook for another 2 minutes. Add the tomatoes and oyster sauce and cook until the tomatoes are just heated through (they should not be allowed to become mushy). Return the beef to the wok, heat through, and serve at once.

I pound lean market or New York steak
I tablespoon light soy sauce
2 teaspoons rice wine or dry sherry
2 teaspoons cornstarch
½ pound yellow onions
I pound fresh tomatoes
2 tablespoons peanut oil
2 tablespoons water
3 tablespoons oyster sauce

Mango Beef

Shopping List

1 pound lean market or New York steak 2 fresh mangoes

Preparation Time: 15 minutes **Cooking Time:** 3 to 4 minutes **Serves:** 4 to 6

I pound lean market or New York steak
I tablespoon plus I teaspoon light soy sauce
3 teaspoons rice wine or dry sherry
2 teaspoons cornstarch
2 fresh mangoes
I ½ tablespoons peanut oil
2 teaspoons dark soy sauce This is an example of the new Hong Kong cuisine, and it is fast as well. Hong Kong chefs have adapted the exotic mango to new uses, as in this recipe. The soft texture and sensual sweetness of the fruit offer a wonderful contrast and complement to the sturdy, familiar virtues of beef. Most of the work involved is preparatory; the cooking takes but a few minutes. Mango beef is delicious and impressive enough to serve as a main course for either a family or a formal meal.

R E C I P E

Cut the beef into 2-by-1/4-inch slices and put them into a bowl. Add I tablespoon of the light soy sauce, 2 teaspoons of the rice wine, and the cornstarch and mix well.

Peel the mangoes and cut them into thick slices, discarding the stones.

Heat a wok or large skillet, then pour in the oil. Add the beef and stir-fry for 2 minutes to brown. Add the remaining I teaspoon light soy sauce, the dark soy sauce, and the remaining I teaspoon rice wine and stir-fry for 30 seconds. Then add the mango slices and heat them through. Give the mixture a final turn and serve at once. The beef should be slightly undercooked, as it will continue to cook for a short time after it is removed from the wok.

Spicy Szechwanstyle Beef

I love the spicy intricacies of Szechwan cooking, and I often prepare dishes using Szechwan seasonings. So distinctive are they that they make even a quick and easy dish into something quite special, as in this recipe. Beef flavor has so much character that it bears the Szechwan treatment gracefully. The preparation of the ingredients for this recipe takes some time, but the actual cooking time is very short. Serve it with rice noodles or egg noodles and your favorite green vegetable.

R E C I P E

Cut the beef into thick 2-by-1/4-inch slices and put them into a bowl. Add the soy sauce, rice wine, and cornstarch and mix well.

Heat a wok or large skillet until it is very hot, then add the oil, chilies, garlic, and salt. Stir-fry for 5 seconds and add the beef. Continue cooking for 3 minutes, then add the sugar, chili bean paste, and green onions. Give the mixture two stirs and serve.

Shopping List

1 pound lean market or New York steak Green onions 2 fresh hot chilies Garlic

Preparation Time: 15 minutes **Cooking Time:** 4 minutes **Serves:** 4 to 6

I pound lean market or New York steak

2 teaspoons dark soy sauce

I teaspoon rice wine or dry sherry

I teaspoon cornstarch

1 ½ tablespoons peanut oil

2 fresh hot chilies, seeded and minced

5 garlic cloves, thinly sliced

I teaspoon salt

2 teaspoons sugar

2 teaspoons chili bean paste

6 green onions, finely shredded

Fast Spicy Meat Sauce for Noodles

Shopping List

1 pound ground pork Garlic Green onions Fresh ginger

Preparation Time: 10 to 15 minutes Cooking Time: 8 minutes

Serves: 4 to 6

1 1/2 tablespoons peanut oil 2 tablespoons coarsely chopped garlic

3 tablespoons coarsely chopped green onions

2 tablespoons coarsely chopped

dry sherry

2 tablespoons hoisin sauce

I teaspoon salt 2 teaspoons sugar

fresh peeled ginger I pound ground pork I tablespoon chili bean paste I tablespoon dark soy sauce 2 tablespoons rice wine or

implicity itself, this marvelously tasty meat sauce transforms a lowly plate of noodles into an impressive meal. If you expect a large crowd, simply expand the recipe proportionately. The sauce freezes well, so you could make several batches and freeze what you do not need immediately. You can substitute ground beef for the pork if you wish. For quick and successful informal entertaining, this dish cannot be beaten.

R E C I P E

Heat a wok or large skillet, then add the oil. Add the garlic, green onions, and ginger and stir-fry for 1 minute. Then add the pork and stir-fry for 2 minutes. Add the chili bean paste, soy sauce, rice wine, hoisin sauce, salt, and sugar and continue to cook for another 5 minutes. Serve with noodles or over rice.

Fifteen-Minute Steak

nce in a while, a good steak is just the right thing to prepare. It is certainly quick and easy, and when you add these Chinese seasonings the appeal of the steak, which lends itself well to grilling, is enhanced in many ways. Serve it with rice and your favorite vegetable and you will have a wholesome and appetizing meal.

R E C I P E

Preheat the broiler or light a fire in an open grill. Rub the steak with the salt, pepper, and toasted sesame oil. When the broiler is hot or the coals are covered with gray ash, cook the steak on one side for $7\frac{1}{2}$ minutes. Turn the steak over and cook the other side for another $7\frac{1}{2}$ minutes for medium-rare. Allow the steak to rest for 10 minutes before slicing.

Just before you are ready to serve, combine the green onions, ginger, and oyster sauce. Heat the oil in a small pan until it is smoking and pour this over the green onion mixture. Ladle the mixture over the steak and serve at once.

Shopping List

1½ pounds lean market or New York steak Green onions Fresh ginger

Preparation Time: 12 minutes Cooking Time: 15 minutes

Serves: 4

1 ½ pounds lean market or New York steak

I teaspoon salt

½ teaspoon freshly ground black pepper

2 teaspoons toasted sesame oil

1/4 cup coarsely chopped green onions

2 teaspoons coarsely chopped peeled fresh ginger3 tablespoons oyster sauce

tablespoons byster sauce

2 tablespoons peanut oil

Stir-fried Beef with Onions and Mint

Quick Orange-Lemon Chicken Page 68

Stir-fried Beef with Onions and Mint

Shopping List

1 pound lean market or New York steak ½ pound yellow onions Fresh mint

Preparation Time: 15 minutes **Cooking Time:** 7 minutes

Serves: 4 to 6

I pound lean market or New York steak 2 teaspoons light soy sauce I teaspoon rice wine or dry sherry I teaspoon cornstarch ½ pound yellow onions 2 tablespoons peanut oil 3 tablespoons water 2 tablespoons oyster sauce Small handful of fresh mint leaves Stir-frying beef is the quick and easy technique par excellence. Once the beef is thinly sliced, it congenially combines with any vegetable and cooks very rapidly. Beef, of course, has its own distinct taste, but it has enough character to play nicely with other assertive flavors. Here, I borrow from Southeast Asian cuisine and add a touch of refreshing mint (you can substitute fresh basil if you wish). Serve this with rice and you will have a wholesome and satisfying one-dish meal

R E C I P E

Cut the beef into 2-by-1/4-inch slices and put them into a bowl. Add the soy sauce, rice wine, and cornstarch and mix well. Peel the onions and cut them into thick slices.

Heat a wok or large skillet, then pour in the oil. Add the beef and stir-fry for I minute to brown. Remove the beef with a slotted spoon and set aside. Add the onions to the wok and stir-fry for I minute. Pour in the water and cook for 3 minutes. Drain the juices from the beef into the wok and add the oyster sauce. Return the beef to the wok and add the mint leaves. Continue to stir-fry for another minute. Serve at once.

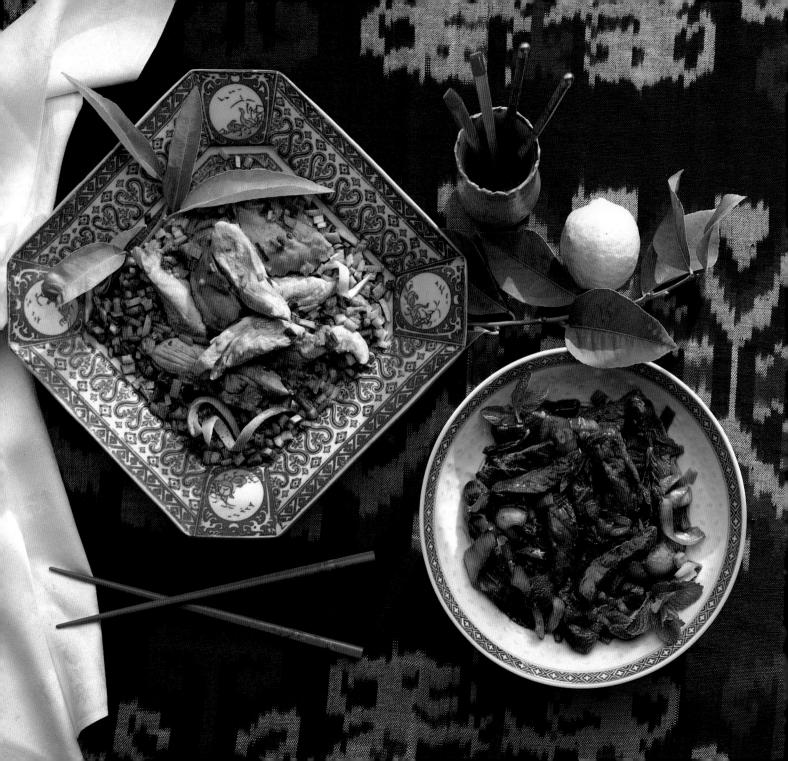

Stir-fried Pork with Pineapple

Shopping List

1 pound lean pork
1 small fresh pineapple, about 1 to
1½ pounds
½ pound fresh peas, shelled, or
¼ cup frozen peas
Green onions

Preparation Time: 20 minutes **Cooking Time:** 6 minutes **Serves:** 4 to 6

I pound lean pork
tablespoons light soy sauce
teaspoon rice wine or dry sherry
teaspoon salt
teaspoons cornstarch
small fresh pineapple, about I to
I½ pounds

½ pound fresh peas, shelled, or
 ¼ cup frozen peas
 ½ tablespoons peanut oil

2 tablespoons coarsely chopped green onions

2 teaspoons dark soy sauce 2 teaspoons sugar

½ teaspoon cornstarch mixed with ½ teaspoon water

Pork is so distinctly flavorsome that it goes nicely with practically any other assertive ingredient—in this case pineapple. The sweet, slightly acidic fruit blends easily with the pork, while fresh peas add a textural and colorful dimension. Veal may successfully be substituted for the pork if you prefer it. This unusually appetizing dish is an ideal centerpiece for a family dinner or a meal for friends, and it is quick and easy to prepare.

R E C I P E

Slice the pork into 3-by- $\frac{1}{2}$ -inch strips and combine them with 1 tablespoon of the light soy sauce, the rice wine, $\frac{1}{2}$ teaspoon of the salt, and the cornstarch in a bowl.

With a sharp knife, remove the skin of the pineapple. Cut the flesh into 1-inch cubes, discarding the tough center core.

If you are using fresh peas, blanch them in boiling water for 2 minutes, drain, and set aside. If you are using frozen peas, let them thaw at room temperature.

Heat a wok or large skillet, then add the oil, the remaining $\frac{1}{2}$ teaspoon salt, and the green onions. Stir-fry the mixture for 10 seconds. Then add the pork and stir-fry for 1 minute. Put in the pineapple, peas, the remaining tablespoon of light soy sauce, the dark soy sauce, sugar, and the cornstarch-water mixture. Cook for 2 more minutes, or until the pork is just done; it should be firm when it has reached this stage. Serve at once.

Stir-fried Pork with Lichees

Pork is the red meat of China but, even so, it is almost always served as an accompaniment to other non-meat foods. In this recipe, it is paired with lichee fruit. Try to use fresh lichees: their tangy, grape-like flavor goes nicely with that of pork, at once complementing and contrasting with it. Serve over rice.

Shopping List

1 pound lean pork
½ pound lichee fruit, fresh or
canned
Green onions
Garlic

Preparation Time: 15 minutes (if using canned lichees) or 21 minutes (if using fresh lichees) Cooking Time: 3 to 4 minutes

Serves: 4 to 6

R E C I P E

Cut the pork into 2-by-1/4-inch slices and put them into a bowl. Add the soy sauce, rice wine, toasted sesame oil, and cornstarch, and mix well.

If you are using fresh lichees, peel and seed them. Set aside. If you are using canned lichees, drain off the liquid (which you will not need in this recipe) and set the fruit aside.

Heat a wok or large skillet, add the peanut oil and garlic, and stir-fry for 10 seconds. Add the pork and continue to stir-fry for $1\frac{1}{2}$ minutes, or until it is just cooked through. Add the lichees and continue to stir-fry for another 30 seconds to warm them through. Garnish with the chopped green onions and serve at once.

I pound lean pork

2 teaspoons light soy sauce

2 teaspoons rice wine or dry sherry

I teaspoon toasted sesame oil

2 teaspoons cornstarch

½ pound lichee fruit, fresh or canned

1 1/2 tablespoons peanut oil

2 tablespoons coarsely chopped garlic

2 tablespoons coarsely chopped green onions

Marinated Broiled Pork Chops

Shopping List 1 pound pork chops

Preparation Time: 5 minutes Cooking Time: 7 minutes Serves: 4

I teaspoon dark soy sauce
I teaspoon light soy sauce
2 teaspoons rice wine or dry sherry
2 teaspoons hoisin sauce
I teaspoon toasted sesame oil
I pound pork chops

nother name for this recipe could well be Lazy Pork Chops. When I am very tired but still hungry for good food, I simply bathe pork chops quickly in a spicy marinade and then almost literally toss them under the broiler. They are done in a jiffy and are delicious with a nice salad that I put together while the chops are broiling. In 15 minutes you have a grand dinner for a lazy (or tired) person. Veal chops work well in this recipe too.

R E C I P E

Preheat the broiler. Mix together the soy sauces, rice wine, hoisin sauce, and toasted sesame oil. Turn the pork chops in the mixture to ensure that they are well coated. Lay the chops on a baking tray and broil for about $3\frac{1}{2}$ minutes on one side, then turn them over and cook the other side for another $3\frac{1}{2}$ minutes, or until cooked through. Serve at once.

Custard with Ground Pork, Green Onions, and Oyster Sauce

This sounds complicated, but it is quite simple to prepare. Cracking the eggs and chopping the onions take the most time: 5 minutes. The ground meat cooks very quickly. As a child, I watched my mother make this dish many times. Served with rice and vegetables, it is a fine, nutritious family meal.

Shopping List

6 eggs
½ pound ground pork
Green onions

Preparation Time: 12 minutes **Cooking Time:** 12 minutes

Serves: 4 to 6

R E C I P E

Set a rack in a wok or deep pan. Add water to a depth of $2\frac{1}{2}$ inches and bring it to a simmer. Cover tightly.

Combine the eggs, pork, green onions, salt, and soy sauce and mix well. Pour this into a heatproof dish and set the dish on the rack in the wok. Cover tightly and steam slowly for 12 minutes or until the custard has just set.

Remove the dish from the steamer and drizzle with the oyster sauce mixture. Serve at once.

6 eggs, beaten

½ pound ground pork

1/4 cup coarsely chopped green onions

1½ teaspoons salt

2 teaspoons light soy sauce

2 tablespoons oyster sauce mixed with I teaspoon water

Do-ahead Reheatable Black Bean Spareribs

Shopping List

2 pounds pork spareribs ½ pound yellow onions Green onions Garlic Fresh ginger

Preparation Time: 15 minutes **Cooking Time:** 50 to 55 minutes

Serves: 4 to 6

2 pounds pork spareribs 1½ tablespoons peanut oil

3 tablespoons coarsely chopped salted black beans

3 tablespoons coarsely chopped green onions

1½ tablespoons finely chopped garlic

I tablespoon finely chopped peeled fresh ginger

1/2 pound yellow onions, sliced

²∕₃ cup rice wine or dry sherry

⅔ cup water

2 tablespoons dark soy sauce

2 tablespoons light soy sauce

2 teaspoons sugar

I tablespoon toasted sesame oil

Braised dishes make for quick and easy reheating. They require a long cooking time in order to bring out their flavor, but once they have been cooked (which can be done days ahead), reheating only improves them. I like to make this dish the night before, then let it cool, remove any fat, cover it, and put it in the refrigerator; I then reheat it when I get home. It also freezes extremely well. The dish is lovely on a cool day with rice and vegetables.

R E C I P E

Cut the spareribs into individual ribs and set aside. Heat a wok or large skillet and add the oil. Brown the spareribs and remove them to a large heavy saucepan or flameproof casserole. Add the black beans, green onions, garlic, and ginger and stir-fry for 10 seconds. Add the onions and continue to stir-fry for an additional 2 minutes. Then add the rice wine, water, soy sauces, and sugar. Bring the mixture to a boil. Pour this over the spareribs in the saucepan or casserole and simmer, covered, for 40 minutes or until the ribs are tender.

Uncover and cook over high heat for 5 minutes to reduce the sauce, then stir in the toasted sesame oil. Serve at once, or allow to cool and reheat when needed.

Barbecued Chinese Spareribs

nce the preliminary cooking of the ribs is done—and it may be accomplished well ahead of time—this is definitely a quick dish, perfect for a summer evening barbecue. Serve it with a salad and perhaps another vegetable, and nice crisp baguettes. These spareribs are made for informal entertaining, precisely because most of the work can be done in advance. The slow cooking melts away the fat and helps to tenderize the meat.

R E C I P E

Preheat the oven to 275°. Place the spareribs in an ovenproof dish. Sprinkle them evenly with the salt and pepper. Bake the spareribs in the oven for 1½ hours. Combine the barbecue sauce ingredients in a blender and mix for 15 to 20 seconds, or until pureed. Add the sauce to the spareribs and turn to coat evenly. Increase the oven to 350°. Bake the coated spareribs for 30 minutes. Serve at once.

Shopping List

3 pounds pork spareribs Fresh ginger Tomato paste Garlic

Preparation Time: 21 minutes Cooking Time: 1½ hours, plus 30 minutes

Serves: 4

3 pounds pork spareribs ½ teaspoon salt ½ teaspoon coarsely ground black pepper

Barbecue Sauce

2 tablespoons light soy sauce

2 tablespoons hoisin sauce

2 tablespoons tomato paste

4 large garlic cloves, peeled 2 tablespoons coarsely chopped

peeled fresh ginger

2 tablespoons rice wine or dry sherry

I tablespoon sugar

I tablespoon toasted sesame oil

2 teaspoons chili bean paste

Chinese Lamb Curry

Shopping List

2½ pounds lamb shoulder or lamb breast 1 pound potatoes ½ pound carrots Garlic Fresh ginger

Preparation Time: 18 minutes **Cooking Time:** 45 minutes **Serves:** 4 to 6

2½ pounds lamb breast
1½ tablespoons peanut oil
2 tablespoons coarsely chopped garlic
1 tablespoon coarsely chopped peeled fresh ginger
½ cups water
3 tablespoons light soy sauce
2 tablespoons dark soy sauce
6 tablespoons curry powder or paste
1 tablespoon sugar

I pound potatoes ½ pound carrots, trimmed

amb is typically a northern Chinese food, but the ingenious chefs of the south have taken it and blended it with a familiar Southeast Asian seasoning, curry. This combination appeals to the southern Chinese palate: curry is a familiar seasoning and assertive enough to mask the strong taste of the lamb, a taste that most Chinese do not particularly relish.

Chinese lamb curry is excellent for entertaining because it can be prepared ahead of time and simply reheated when needed—and it is even tastier then. If you wish, you can prepare the dish in advance up to the point at which the vegetables are added, then complete it, cooking the vegetables just before you are ready to serve. It goes well with rice and perhaps a salad.

R E C I P E

Cut the lamb meat from the bone and then cube it. Blanch it in boiling water for 10 minutes. Drain and place in a flameproof casserole.

Heat a wok or large skillet, add the oil, garlic, and ginger, and stir-fry for 10 seconds. Add the water, soy sauces, curry powder, and sugar, and bring the mixture to a boil. Pour the liquid over the lamb in the casserole and bring to a boil again. Cover and simmer for 35 minutes, or until the meat is tender.

Peel the potatoes and cut them into 1-inch cubes. Peel the carrots and cut them into 1-inch lengths. Skim the fat from the curry and add the vegetables. Cook for another 10 minutes, or until the vegetables are tender, then serve.

Hot and Tangy Ground Lamb

I amb has a very assertive taste even when it is ground; thus we can use hot and tangy sauces with it and its flavor is still recognizable but more palatable. As is the case with meat preparations in general, this lamb dish, in which the flavors of East and West meet, readily combines with pasta, rice, noodles, or even bread, to make a quick, easy, and substantial meal for 4 to 6 people in less than 30 minutes. You can use ground beef instead of lamb if you wish.

R E C I P E

Combine the sauce ingredients and set aside. Heat a wok or large skillet, then add the oil and lamb. Stir-fry for 2 minutes and add the garlic and ginger. Continue cooking for another minute, then stir in the sauce. Cook for another 4 minutes. Serve at once.

Shopping List

1 pound ground lamb 1 lemon Garlic Tomato paste Fresh ginger

Preparation Time: 15 minutes Cooking Time: 8 minutes Serves: 4 to 6

Sauce

- 2 tablespoons tomato paste
- 2 tablespoons sesame paste or peanut butter
- 1½ tablespoons dark soy sauce 1 tablespoon fresh lemon juice
- I tablespoon chili bean paste
- 2 teaspoons sugar
- I tablespoon rice wine or dry sherry
- I tablespoon peanut oil I pound ground lamb
- 3 tablespoons coarsely chopped
- 3 tablespoons coarsely chopped garlic
- 2 tablespoons coarsely chopped peeled fresh ginger

Grilled Lamb Chops with Chinese Marinade

Shopping List

1 pound thick lamb chops Green onions Garlic Fresh ginger

Preparation Time: 10 minutes **Cooking Time:** 10 to 15 minutes

Serves: 2

½ teaspoon salt I pound thick lamb chops

Marinade

- I tablespoon finely chopped garlic 2 teaspoons finely chopped peeled
- fresh ginger
- 3 tablespoons finely chopped green onions
- 2 tablespoons rice wine or dry sherry
- I tablespoon hoisin sauce
- I tablespoon light soy sauce

rilling is a popular Western cooking technique, whether outdoors on the open grill or indoors under the broiler. Grilled foods cook quickly and easily and, as a bonus, the juices and flavor of meat are sealed inside during grilling by the searing heat. In this recipe the Chinese seasonings permeate the meat, resulting in a very tasty dish—still definitely lamb, but with a spicy twist. Serve it with vegetables or salad and your favorite bread.

For a more quickly grilled meal substitute chicken breasts, which should cut the cooking time down to about 7 minutes.

R E C I P E

Preheat the broiler or light a fire in an open grill. Lightly salt the lamb chops. Mix the marinade ingredients together in a small bowl. Rub the lamb chops on both sides with the marinade and let stand for 5 minutes. When the broiler is hot or the coals are covered with gray ash, cook the lamb chops for about 4 to 5 minutes on each side for medium-rare chops. Serve at once.

Do-ahead Reheatable Lamb Stew

You may have detected a trace of ambivalence on my part concerning lamb: I recognize its virtues but I am not keen about its unmediated taste. Thus, I tend to surround it with seasonings and spices that tame its more aggressive aspects, as in this recipe. The long simmering process allows the seasonings to penetrate (and neutralize) the lamb, tenderizing it at the same time. You can substitute stewing veal or beef for the lamb if you wish, but remember that stewing beef will take longer to cook. This is a quick and easy dish because it can be made ahead of time and frozen until needed. Serve it with rice and your favorite salad or green vegetable.

Shopping List

2½ pounds lamb leg or shoulder meat Garlic Fresh ginger

Preparation Time: 20 minutes Cooking Time: 1 hour and 35 minutes Serves: 4

R E C I P E

Cut the lamb into 1-inch cubes. Heat a wok or large skillet, then add the oil. Add the lamb, sprinkle with the pepper, and slowly brown on all sides. Transfer the meat to a large flameproof casserole. Pour all but 1 tablespoon of oil from the wok. Reheat the wok and add the garlic and ginger. Stir-fry for 20 seconds and add the rest of the ingredients. Bring the mixture to a boil and pour it over the lamb in the casserole. Simmer for $1 \frac{1}{2}$ hours, or until the lamb is tender.

2½ pounds lamb leg or shoulder meat
2 tablespoons peanut oil
½ teaspoon freshly ground pepper
6 garlic cloves, peeled and crushed
6 slices fresh peeled ginger
5 cups water
2 tablespoons five-spice powder
⅓ cup sesame paste or peanut butter
6 tablespoons hoisin sauce
3 tablespoons light soy sauce
⅓ tablespoons dark soy sauce
⅓ cup rock or granulated sugar
I tablespoon chili bean paste

Oyster Sauce Asparagus Page 104

of all the foods we normally cook, vegetables are undoubtedly the quickest and easiest to prepare. They are generally delicate in flavor and cook rapidly. Thus we need to take great care that we cook them to just the right point or risk losing their natural taste, juice, color, texture, and food value.

The Chinese are masters of the art of vegetable cooking, and stirfrying is the perfect technique for vegetables. This rapid method of cooking over high heat retains all of the virtues of the food and leaves it neither raw nor mushy: it is a pleasure to eat. Almost all vegetables may be stir-fried, as the recipes here indicate. Follow them but adapt them to your own taste. Use vegetables in season imaginatively and creatively.

- I. Oyster Sauce Asparagus
- 2. Quick Bean Curd in Spicy Chili Sauce
- 3. Oyster Sauce Bean Curd
- 4. Hot and Spicy Stir-fried Cabbage
- Stir-fried Eggs and Corn with Green Onions and Ginger
- 6. Stir-fried Fennel with Garlic
- 7. Bright Pepper and Green Bean Stir-fry
- 8. Stir-fried Fava Beans with Ham and Green Onions
- Stir-fried Peas with Cilantro, Green Onions, and Sesame Oil
- Potatoes With Cilantro, Green Onion, and Sesame Oil Dressing
- 11. Fast Snow Peas with Mushrooms
- 12. Stir-fried Ginger Spinach
- 13. Potatoes in Curry-Coconut Sauce
- 14. Red-cooked Winter Vegetables
- 15. Chinese-style Omelette
- 16. Hot and Tangy Zucchini

Oyster Sauce Asparagus

Shopping List 1½ pounds fresh asparagus Green onions Garlic

Preparation Time: 15 minutes Cooking Time: 5 minutes Serves: 4

I½ pounds fresh asparagus, trimmed
I½ tablespoons peanut oil
2 tablespoons thinly sliced garlic
2 tablespoons coarsely chopped green onions
½ teaspoon salt
Pinch of sugar
4 cup water
2 tablespoons oyster sauce

When asparagus is in season, enjoy it as much as possible; it is a superb vegetable, the favorite of many people. I never tire of it and am sad when its season ends. Here I combine it with a savory oyster sauce. This has a robust flavor that the asparagus readily accepts, and the result is as satisfying as a meat and vegetable dish. Serve it by itself or as part of a family meal.

R E C I P E

Cut the asparagus into 3-inch lengths and set aside. Heat a wok or large skillet until it is hot and add the oil. Then add the garlic and green onions and stir-fry for 30 seconds. Add the asparagus, salt, and sugar and stir-fry for 1 minute. Add the water, cover, and cook for 3 minutes. Then add the oyster sauce, stir to mix well, and serve at once.

Quick Bean Curd in Spicy Chili Sauce

This is my version of the classic Szechwan bean curd dish. I have simplified the process, but it is as colorful and tasty as the original. Serve it to accompany a main meal with rice. Leftovers from this dish can be put into stock to make a quick soup.

Shopping List
1 pound firm bean curd
Garlic
Fresh ginger
Tomato pasto

Tomato paste Green onions

Preparation Time: 11 minutes Cooking Time: 9 minutes

Serves: 4 to 6

R E C I P E

Heat a wok or large skillet, then add the oil, garlic, ginger, and green onions. Stirfry the mixture for 30 seconds, then add all the remaining ingredients except the bean curd. Simmer the mixture for 5 minutes. While the sauce is simmering, cut the bean curd into $\frac{1}{2}$ -inch dice. Add the diced bean curd to the sauce and simmer for another 3 minutes. Serve at once.

- I tablespoon peanut oil
- I tablespoon coarsely chopped garlic
- 2 teaspoons finely chopped peeled fresh ginger
- 3 tablespoons coarsely chopped green onions
- 3 tablespoons water
- I tablespoon yellow bean sauce
- I tablespoon tomato paste
- 2 teaspoons chili bean paste
- 2 teaspoons dark soy sauce
- 2 teaspoons sugar
- 2 teaspoons toasted sesame oil
- I pound firm bean curd

Vegetables 105

Oyster Sauce Bean Curd

Shopping List1 pound firm bean curd
Garlic

Preparation Time: 9 minutes **Cooking Time:** 12 minutes

Serves: 4

I pound firm bean curd
3 tablespoons peanut oil
2 garlic cloves, peeled and crushed
3 tablespoons oyster sauce
2 tablespoons water
I teaspoon sugar
2 teaspoons toasted sesame oil

B ean curd (tofu) is an inexpensive, very nutritious food that is also delicious when combined with appropriate seasonings and properly cooked. Here oyster sauce and pan-frying create a most enjoyable bean curd dish.

R E C I P E

Cut the bean curd into 1-inch cubes. Heat a wok or large skillet, then add the oil. Slowly fry the bean curd on each side until it is golden brown—you may have to do this in several batches. Remove and drain on paper towels. Pour off from the wok all but 1 tablespoon of oil.

Reheat the wok and remaining oil, add the garlic, and stir-fry for 10 seconds. Then add the oyster sauce, water, sugar, and toasted sesame oil. Bring to a simmer, return the bean curd cubes to the wok, and heat them through. Serve at once.

Hot and Spicy Stir-fried Cabbage

Cabbage has a distinct but delicate flavor that adapts well to a wide range of seasonings. Because it is a "cold" vegetable, I believe that it needs the assistance or enhancement of something like zesty Szechwan spices, as in this recipe. This easy-to-make dish makes a delicious accompaniment to all types of main courses. With rice and another quick vegetable dish, it may also serve as part of a vegetarian meal. You can use Napa cabbage if you wish.

Shopping List 1 pound cabbage

Preparation Time: 8 minutes Cooking Time: 5 minutes

Serves: 4 to 6

R E C I P E

Bring a large pot of salted water to a boil. Cut the cabbage into strips about $\frac{1}{2}$ inch wide. Blanch the cabbage in the hot water for 2 minutes—this removes any harshness of flavor and brings out the sweet taste. Drain thoroughly.

Heat a wok or large skillet, then add the oil, garlic, and ginger. Stir-fry for about 10 seconds and add the cabbage. Continue stir-frying for 2 minutes, then add the soy sauce, oyster sauce, bean paste, and toasted sesame oil and cook for another 2 minutes. Serve at once.

I pound cabbage, trimmed

1½ tablespoons peanut oil 2 tablespoons coarsely chopped

2 tablespoons coarsely chopped garlic

I tablespoon coarsely chopped peeled fresh ginger I tablespoon dark soy sauce

I tablespoon oyster sauce

2 teaspoons chili bean paste

2 teaspoons toasted sesame oil

Stir-fried Eggs and Corn with Green Onions and Ginger

Shopping List: 1 pound fresh corn on the cob or ²/₃ pound frozen kernels 4 eggs Green onions Fresh ginger

Preparation Time: 10 minutes Cooking Time: 5 minutes

Serves: 4

- I pound fresh corn on the cob, or 1/3 pound (I cup) frozen corn kernels
- I tablespoon peanut oil
- 3 tablespoons coarsely chopped green onions
- 2 teaspoons finely chopped peeled fresh ginger
- I teaspoon salt
- 4 eggs, lightly beaten

I often make this dish when I need a sustaining nutritious meal in a hurry. Corn has made its way from the West to China, and in Hong Kong especially you will find it a popular food. As this delicious combination indicates, Chinese chefs have thoroughly integrated this vegetable into the Chinese cuisine. You can substitute fresh or frozen peas for the corn if you wish.

R E C I P E

If you are using fresh corn on the cob, clean it and remove the kernels with a sharp knife or cleaver; you should end up with about 1 cup. Set it aside. If you are using frozen corn, place it in a bowl and let it thaw at room temperature.

Heat a wok or large skillet, then add the oil. Add the green onions, ginger, and salt and stir-fry for 10 seconds. Add the corn and continue to stir-fry for 2 minutes. Finally, reduce the heat to medium, add the eggs, and continue to cook for another 2 minutes. Serve at once.

Stir-fried Fennel with Garlic

n my frequent visits to England, I like to cook "Chinese/English" for friends. On such occasions I always prepare vegetables in season. I recently discovered that fennel is delicious stir-fried. I had, of course, long been familiar with its licorice-flavored herbal qualities. But, even though I knew it as a popular dish in the south of France and in Italy, I had never prepared it as a vegetable dish. Serve it with one of the quick grilled chop recipes and you will have a very satisfying meal.

Shopping List
1 pound fresh fennel
½ pound red bell peppers
Garlic

Preparation Time: 10 minutes **Cooking Time:** 6 minutes **Serves:** 4 to 6

R E C I P E

Trim the fennel and quarter it, separating the layers. Core and seed the peppers and cut them into strips.

Heat a wok or large skillet, then add the oil, garlic, and salt. Stir-fry for 10 seconds and add the fennel, peppers, and water. Continue to stir-fry for 5 minutes, or until the vegetables are cooked through, if necessary adding more water to keep them from burning. Serve at once.

I pound fresh fennel 1/2 pound red bell peppers I 1/2 tablespoons peanut oil 4 garlic cloves, peeled and crushed I teaspoon salt 2 tablespoons water

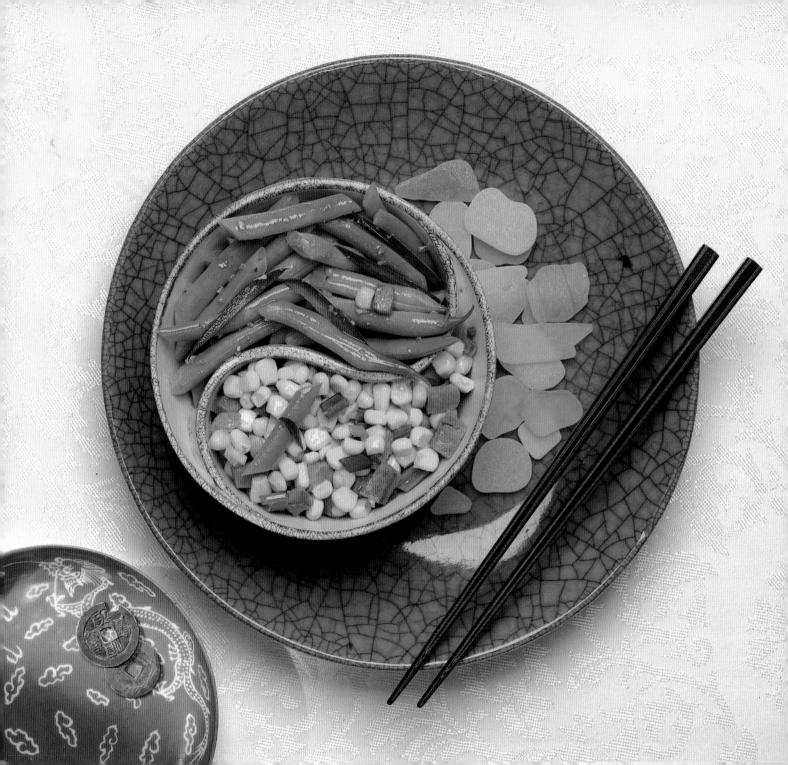

Stir-fried Fava Beans with Ham and Green Onions (with corn as an option) Page 112

Bright Pepper and Green Bean Stir-fry

Bright Pepper and Green Bean Stir-fry

R ed peppers and green beans, nicely seasoned, combine to form a colorful blend of tastes and textures, a nutritious and attractive vegetable salad appropriate for any meal: very quick, very easy, very satisfying. This dish is also good served at room temperature.

R E C I P E

Core and seed the peppers and cut them into strips. Heat a wok or large skillet, then add the oil. Add the garlic, salt, peppers, and beans and stir-fry for 2 minutes. Then add the sugar and water and continue to cook for another 4 minutes, or until the vegetables are tender. Serve at once.

Shopping List

½ pound red bell peppers ½ pound green beans Garlic

Preparation Time: 15 minutes **Cooking Time:** 7 minutes **Serves:** 4 to 6

½ pound red bell peppers
 ½ tablespoons peanut oil
 tablespoons coarsely chopped garlic

1½ teaspoons salt½ pound green beans, trimmed and left whole

I teaspoon sugar 2 tablespoons water

Vegetables

Stir-fried Fava Beans with Ham and Green Onions

Shopping List

1½ pounds fresh or 1 pound frozen fava beans3 tablespoons finely chopped Parma ham

Green onions

Preparation Time: 10 minutes **Cooking Time:** 5 to 6 minutes

Serves: 4 to 6

I ½ pounds fresh or I pound frozen fava beans
I ½ tablespoons peanut oil
3 tablespoons finely chopped Parma ham
¼ cup coarsely chopped green onions
I teaspoon salt
2 teaspoons toasted sesame oil

Shanghai-style and quick and easy, this dish can be served as a side dish but is substantial enough to stand on its own. With another vegetable dish, it makes a light, nutritious meal. Fresh or frozen lima beans, peas, or corn may be used instead of fava beans.

R E C I P E

If you are using fresh fava beans, shell them and blanch for 4 minutes in boiling salted water. Drain and set aside. If you are using frozen vegetables, let them thaw at room temperature.

Heat a wok or large skillet, then add the oil. Add the ham and stir-fry for I minute. Then add the fava beans and continue to stir-fry for 3 minutes. Add the green onions and salt and continue to stir-fry for another minute. Stir in the toasted sesame oil and serve at once.

Stir-fried Peas with Cilantro, Green Onions, and Sesame Oil

B ecause of their sweetness and succulent texture, peas are a popular dish in any meal. Here I have enhanced their virtues with some spirited seasonings to make a quick, easy, and tasty dish. Try also serving it at room temperature as part of a buffet.

Shopping List

2 pounds fresh peas, shelled, or 1 pound frozen peas Cilantro Green onions Garlic

Preparation Time: 11 minutes (if using fresh peas) or 5 minutes (if using frozen peas) Cooking Time: 4 minutes Serves: 4 to 6

R E C I P E

If you are using fresh peas, blanch them in boiling water for 2 minutes, drain, and set aside. If you are using frozen peas, let them thaw at room temperature.

Heat a wok or large skillet, then add the oil. Add the peas and stir-fry for 30 seconds, then add the cilantro, green onions, garlic, sugar, salt, and pepper and continue to stir-fry for 3 minutes, or until the peas are cooked. Add the toasted sesame oil, give the mixture a final stir, and serve at once.

- 2 pounds fresh peas, shelled, or I pound frozen peas
- I tablespoon peanut oil
- 2 tablespoons finely chopped fresh cilantro
- 2 tablespoons finely chopped green onions
- 2 teaspoons finely chopped garlic
- I teaspoon sugar
- I teaspoon salt
- 1/2 teaspoon freshly ground white pepper
- 2 teaspoons toasted sesame oil

Potatoes with Cilantro, Green Onion, and Sesame Oil Dressing

Shopping List

1 pound small new potatoes Cilantro Green onions

Preparation Time: 10 minutes **Cooking Time:** 15 minutes **Serves:** 4 to 6

I pound small new potatoes
I teaspoon salt
2 tablespoons white rice vinegar
3 tablespoons finely chopped fresh cilantro

3 tablespoons finely chopped green onions

I tablespoon toasted sesame oil

2 teaspoons peanut oil

Potatoes are known in China but they are not a popular food. Western as I am, however, I have long since discovered and learned to love the virtues of this wholesome vegetable. I especially like new potatoes. The potato's one flaw is that it is rather bland; however, it is also congenially receptive to lively seasonings, as in this recipe. The Chinese spices and herbs lend the potatoes an exotic touch. This easy-to-prepare dish will gracefully accompany a meat dish (particularly a grilled one) at any gathering, formal or informal.

R E C I P E

Scrub the potatoes but do not peel them. Cook them in boiling salted water for about 15 minutes, or until they are just cooked through. Drain them thoroughly and put them into a serving bowl.

In another small bowl, combine the salt, vinegar, cilantro, and green onions. Slowly beat in the oils, pour over the potatoes, toss well, and serve at once.

Fast Snow Peas with Mushrooms

Snow peas are among my very favorite vegetables, and they are so quick and easy to prepare. Combined with softer, meatier mushrooms and enhancing seasonings, as in this recipe, they make a splendid vegetable dish in less than 20 minutes.

R E C I P E

Heat a wok or large skillet, then add the oil and mushrooms. Stir-fry for 4 minutes, then add the snow peas, sugar, soy sauce, and toasted sesame oil. Continue to stir-fry for another 2 minutes. Serve at once.

Shopping List

1 pound snow peas ½ pound small fresh mushrooms

Preparation Time: 10 minutes **Cooking Time:** 7 minutes **Serves:** 4 to 6

1½ tablespoons peanut oil ½ pound small fresh mushrooms, washed

I pound snow peas, trimmed

I teaspoon sugar

2 teaspoons dark soy sauce

2 teaspoons toasted sesame oil

Stir-fried Ginger Spinach

Shopping List 1½ pounds fresh spinach Fresh ginger

Preparation Time: 7 minutes Cooking Time: 5 minutes Serves: 4 to 6

I ½ pounds fresh spinach
I tablespoon peanut oil
2 tablespoons finely shredded peeled fresh ginger
I teaspoon salt
I teaspoon sugar
2 teaspoons toasted sesame oil

The hardest part of this recipe is cleaning the spinach. After that, it is quick, easy, and ginger-delicious all the way!

R E C I P E

Remove the stalks from the spinach leaves. Wash the leaves well in several changes of cold water.

Heat a wok or large skillet, then add the oil, ginger, and salt. Stir-fry the mixture for 20 seconds. Add the spinach and stir-fry for 2 minutes to coat the leaves thoroughly. When the spinach has wilted to about a third of its original size, add the sugar and toasted sesame oil. Continue to stir-fry for another 2 minutes. Serve hot or cold.

Potatoes in Curry-Coconut Sauce

This is essentially a potato stew, but one given new dimensions by savory and exotic seasonings. Moreover, it is ready in little more than 30 minutes, and you can peel the potatoes up to 4 hours in advance and leave them, covered with water, in the refrigerator until you want to cook them. You can also substitute carrots or turnips for the potatoes. The rich flavor and substantial nature of this dish make for a very satisfying vegetarian meal. Serve it with a green vegetable or salad.

Shopping List

1½ pounds potatoes ½ pound yellow onions Garlic Fresh ginger

Preparation Time: 19 minutes **Cooking Time:** 17 minutes **Serves:** 4 to 6

R E C I P E

Peel and cut the potatoes into 1-inch cubes. Peel and coarsely chop the onions. Heat a wok or large skillet, then add the oil, onions, garlic, and ginger. Stir-fry the mixture for 1 minute. Then add the potatoes, curry powder, coconut milk, water, soy sauce, and sugar. Bring the mixture to a simmer, cover, and cook for 15 minutes, or until the potatoes are tender. Serve at once.

1½ pounds potatoes ½ pound yellow onions 1½ tablespoons peanut oil

2 tablespoons coarsely chopped garlic

I tablespoon coarsely chopped peeled fresh ginger

3 tablespoons curry powder or paste

2 cups canned unsweetened coconut milk 1/4 cup water 1 tablespoon light soy sauce

2 teaspoons sugar

Shopping List

1 pound carrots ½ pound turnips Garlic Fresh ginger

Preparation Time: 10 minutes Cooking Time: 12 minutes

Serves: 4

I pound carrots, trimmed ½ pound turnips, trimmed I tablespoon peanut oil 2 garlic cloves, peeled and crushed 2 teaspoons coarsely chopped peeled fresh ginger 3 tablespoons hoisin sauce I tablespoon dark soy sauce 2 teaspoons sugar ¾ cup water

R ed-cooking is usually reserved for meats, which are simmered in a rich red sauce of Chinese spices. The technique works as well, however, with winter root vegetables, making a quick, tasty stew. On a cold winter evening, this dish goes perfectly with meat or poultry and a salad.

R E C I P E

Peel and cut the carrots into 2-inch pieces. Peel the turnips and cut them into 2-inch cubes. Heat a wok or large skillet, then add the oil, garlic, and ginger. Stir-fry for 10 seconds and add the carrots, hoisin sauce, soy sauce, sugar, and water. Cover and cook over high heat for 8 minutes. Add the turnips and continue to cook for another 3 minutes, or until all the vegetables are tender. There should be very little sauce left. Turn onto a platter and serve at once.

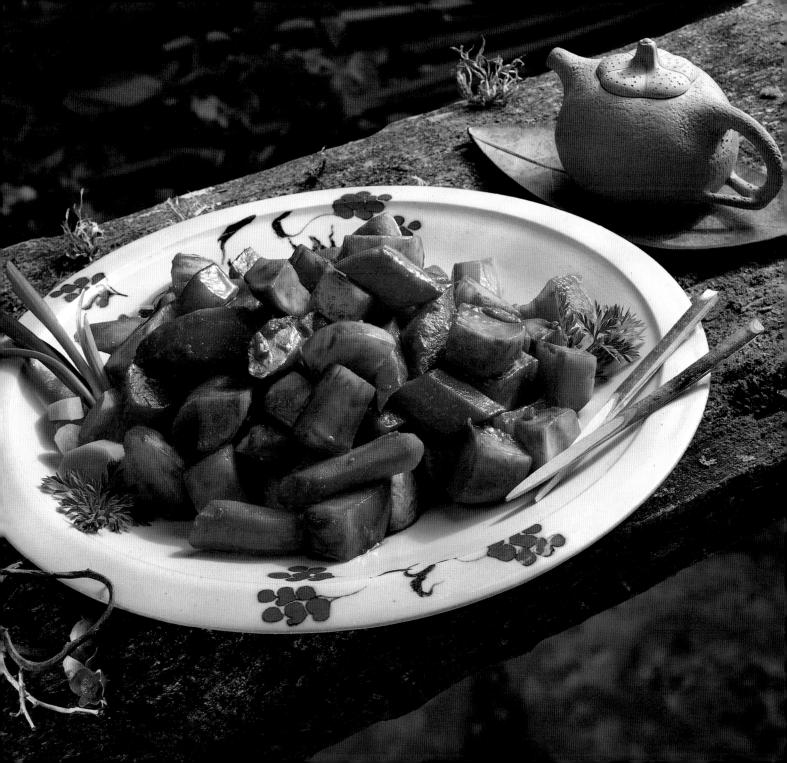

Chinese-style Omelette

Shopping List

6 eggs
½ pound bean sprouts
Green onions
Cilantro

Preparation Time: 9 minutes **Cooking Time:** 4 minutes **Serves:** 4

1½ tablespoons peanut oil
½ teaspoons salt
½ pound bean sprouts
6 eggs, lightly beaten
¼ cup coarsely chopped green onions
2 tablespoons coarsely chopped fresh cilantro
2 tablespoons oyster sauce mixed

with I tablespoon water

A simple omelette is one of life's pleasures. It is an ideal food at the end of a long day when you are hungry but don't have much time or energy to devote to preparing a meal. But it must be done with care and imagination. I often prepare this Chinese-style omelette while my rice is heating. Add a salad or favorite green vegetable, and you will have a very quick and quite refreshing meal in 15 to 20 minutes.

R E C I P E

Heat a wok or large skillet, then add the oil, salt, and bean sprouts. Cook for I minute, then pour in the beaten eggs and add the green onions and cilantro. Allow to cook for 2 minutes, then with a spatula turn half of the omelette over the other half. It should be moist but cooked through. Drizzle the omelette with the oyster sauce mixture and serve at once.

Hot and Tangy Zucchini

Zucchini are easy to prepare and can be elevated from their bland natural state into something quite impressively tangy, as in this recipe. They are made spicy and colorful here, and can grace any table as an accompaniment to a main course. This dish also may be served at room temperature for a warm summer evening meal.

Shopping List 1½ pounds zucchini Garlic

Preparation Time: 9 minutes Cooking Time: 5 minutes Serves: 4 to 6

R E C I P E

Cut the zucchini into 1-inch-thick slices. Heat a wok or large skillet, then add the oil, chili bean paste, garlic, and black beans and stir-fry for 10 seconds. Add the zucchini and stir-fry for 2 minutes. Add the vinegar, rice wine, and water and continue to cook for 2 minutes. Finally, stir in the toasted sesame oil and serve.

1½ pounds zucchini, trimmed

I tablespoon peanut oil

2 teaspoons chili bean paste

I tablespoon coarsely chopped garlic

I tablespoon coarsely chopped salted black beans

2 tablespoons white rice vinegar I tablespoon rice wine or

dry sherry

3 tablespoons water 2 teaspoons toasted sesame oil

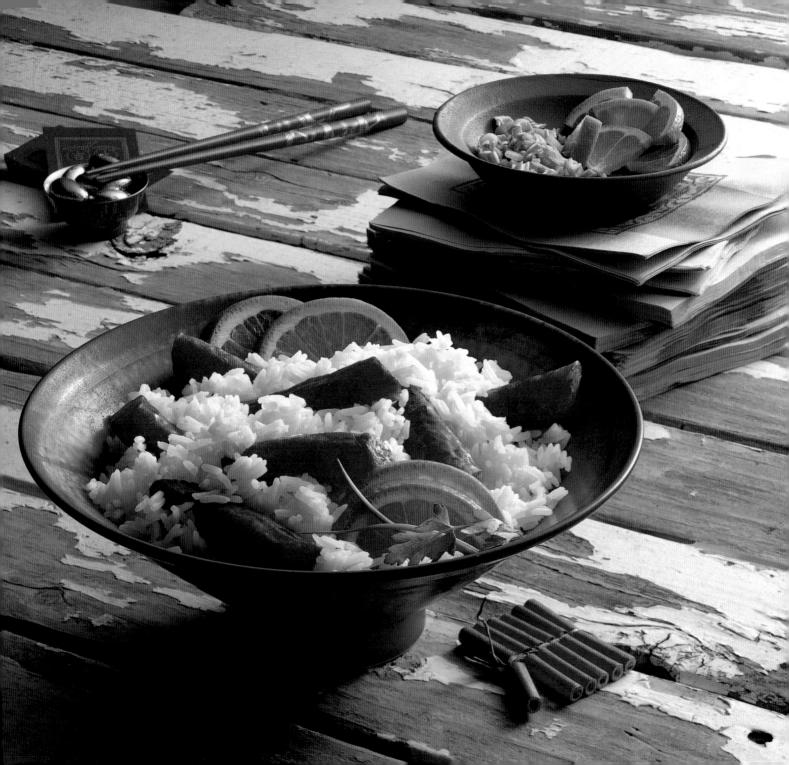

Oodles are among the quickest foods to cook, and rice, while it a takes a little longer, reheats nicely and so can be prepared in advance. Indeed, some rice dishes require reheated rice. Asian cities are filled with street stalls and wagons that sell the area's fast foods, rice and noodles, for a quick meal or snack. These are warming and satisfying dishes, easy to serve and easy to make. They are the perfect base for a one-dish meal.

Some of the preparation for a rice dish can be done ahead of time, and once the rice is made the rest of the dish is rapidly put together. In most of the noodle recipes, I use rice noodles for convenience. These keep indefinitely in their dried state, needing no refrigeration. They require very little cooking—not even the short boiling that egg noodles and pasta need—and can be placed directly into the dish being prepared. If time is really at a premium, rely on rice noodles.

Many of the dishes in this section may serve as part of a larger meal or simply as light meals in themselves—rice and pasta are quite satisfying. Some of the recipes can be served at room temperature for a buffet or as exotic picnic fare. Use them creatively and imaginatively, to suit your own tastes and needs.

- 1. Quick Fried Rice
- 2. Rice with Chinese Sausages
- 3. Green Rice
- 4. Hot and Spicy Rice with Beef
- 5. Bean Sauce Noodles
- 6. Rice Noodles with Broccoli
- 7. Spicy Rice Noodles with Mussels
- 8. Elizabeth Chong's Noodle Salad
- 9. Ground Pork, Peas, and Rice Casserole

Quick Fried Rice

Shopping List

4 eggs Fresh ginger

Preparation Time: Rice, 5 minutes; Quick Fried Rice, 8 minutes Cooking Time: Rice, 25 minutes; Quick Fried Rice, 7 to 8 minutes Serves: 4 to 6

2 cups long-grain rice
3¾ cups water
2 tablespoons peanut oil
2 teaspoons salt
2 tablespoons coarsely chopped peeled fresh ginger
4 eggs, beaten

If you prepare the rice beforehand, this dish takes but 16 minutes from wok to table. You can boil the rice hours or even days in advance and store it, well covered, in the refrigerator. This recipe is typical of the fried rice served in Chinese homes, using just a few simple seasonings to perk up the bland but congenial grain. Serve it as part of a meal with a fast meat or poultry dish and your favorite salad. Alternatively, turn Quick Fried Rice into a speedy one-dish meal by adding leftovers.

R E C I P E

Put the rice in a large, heavy pan with the water and bring it to a boil. Continue boiling for about 10 minutes, or until most of the surface liquid has evaporated. The surface of the rice should have small indentations and look rather like a pitted crater. At this point, cover the pan with a very tight-fitting lid, turn the heat as low as possible, and let the rice cook undisturbed for 15 minutes more. Remove from the heat and allow to cool thoroughly.

Heat a wok or large skillet, then add the oil, salt, and ginger and stir-fry for I minute. Now add the cooked rice and continue to stir-fry another 5 minutes. Stir in the eggs and cook for I minute. Serve at once, or allow to cool and serve at room temperature.

Rice with Chinese Sausages

 $^{f 1}$ his southern Chinese peasant dish is one of my favorites. If you serve it with a vegetable, it makes a very satisfying, sustaining meal, and yet it is so quick and easy to prepare. While the rice and sausage are cooking, prepare a fast stir-fried vegetable dish, and there you are! Try to get Chinese sausages for this recipe they are so sweetly flavored that they are worth the search.

Leftovers from this dish can be swiftly converted into another tasty meal on the following day: simply stir-fry the rice and recombine with the finely chopped sausages and some chopped green onions and beaten eggs for an instant fried rice.

R E C I P E

Put the rice in a large, heavy pan with the water and bring it to a boil. Continue boiling for about 10 minutes, or until most of the surface liquid has evaporated. While the rice is boiling, cut the sausages diagonally into 2-inch segments. By now, the surface of the rice should have small indentations and look rather like a pitted crater. At this point, place the sausages on the top of the rice, cover the pan with a very tight-fitting lid, turn the heat as low as possible, and let the rice cook undisturbed for 15 minutes more. Serve immediately.

Shopping List 3/4 pound Chinese sausages

Preparation Time: 5 minutes Cooking Time: 25 minutes

Serves: 4 to 6

2 cups long-grain rice 3¾ cups water 3/4 pound Chinese sausages

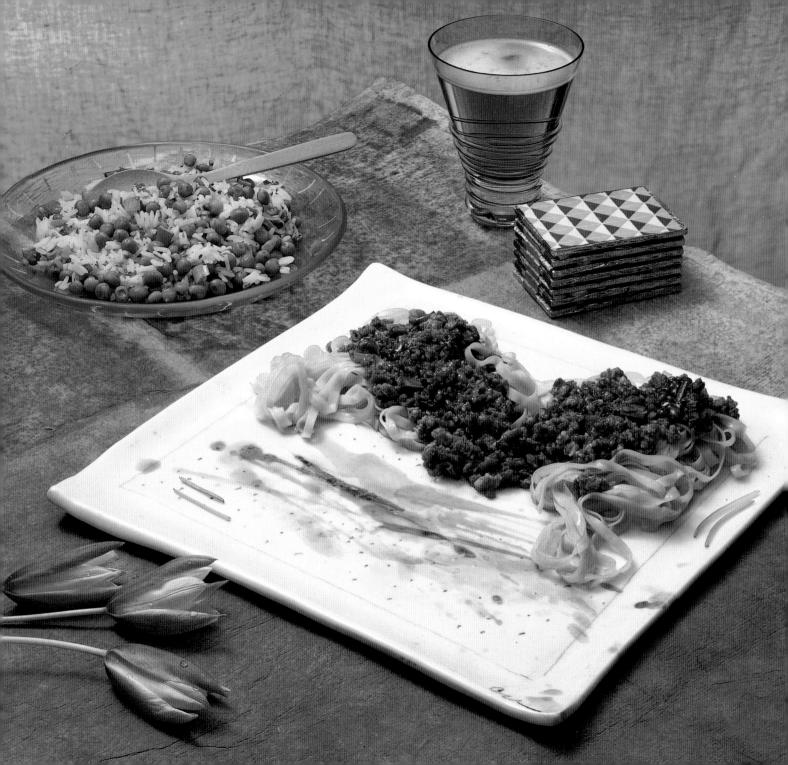

Green Rice

This dish is not really green but is attractively dotted with the green of peas, cilantro, and green onions and redolent with their flavors and pungency. You can speed up the preparation by boiling the rice in advance; store it, well covered, in the refrigerator until you need it. Serve Green Rice at room temperature as a tasty rice salad or as part of a meal.

Shopping List
1 pound fresh peas, shelled, or
½ cup frozen peas

Garlic Cilantro

Green onions

Preparation Time: Rice, 5 minutes; Green Rice, 15 minutes

Cooking Time: Rice, 25 minutes; Green Rice, 7 to 8 minutes

Serves: 4 to 6

R E C I P E

Put the rice in a large, heavy pan with the water and bring it to the boil. Continue boiling for about 10 minutes, or until most of the surface liquid has evaporated. The surface of the rice should have small indentations and look rather like a pitted crater. At this point, cover the pan with a very tight-fitting lid, turn the heat as low as possible, and let the rice cook for 15 minutes more. Allow the rice to cool thoroughly; the colder the rice, the better it stir-fries.

If you are using fresh peas, blanch them in boiling water for 2 minutes, then drain and set aside. If you are using frozen peas, let them thaw at room temperature.

Heat a wok or large skillet, then add the oil. Add the garlic and stir-fry for 10 seconds. Add the rice and continue to stir-fry for 3 minutes. Now add the cilantro, green onions, peas, and salt and continue to stir-fry another 2 minutes. Serve at once or allow to cool and serve at room temperature.

2 cups long-grain rice 3³/₄ cups water

- I pound fresh peas, shelled, or $\frac{1}{2}$ cup frozen peas
- I tablespoon peanut oil
- I tablespoon coarsely chopped garlic
- 3 tablespoons finely chopped fresh cilantro
- 6 tablespoons finely chopped green onions
- 2 teaspoons salt

Hot and Spicy Rice with Beef

Shopping List

1 pound ground beef Garlic Fresh ginger Green onions

Preparation Time: Rice, 5 minutes; Hot and Spicy Rice, 7 minutes Cooking Time: Rice, 25 minutes; Hot and Spicy Rice, 10 minutes Serves: 4 to 6 R ice dishes need not be bland, as the aromatic seasonings and spices in this recipe prove. This can be a one-dish meal; simply serve it with your favorite salad or vegetable. Speed up the preparation by boiling the rice in advance; store it, well covered, in the refrigerator until you need it.

2 cups long-grain rice 3³/₄ cups water

4 tablespoons peanut oil

2 teaspoons salt

I pound ground beef

2 tablespoons coarsely chopped garlic

I tablespoon coarsely chopped peeled fresh ginger

2 teaspoons chili bean paste

I teaspoon curry powder or paste

3 tablespoons coarsely chopped green onions

R E C I P E

Put the rice in a large, heavy pot with the water and bring it to a boil. Continue boiling for about 10 minutes, or until most of the surface liquid has evaporated. The surface of the rice should have small indentations and look rather like a pitted crater. At this point, cover the pot with a very tight-fitting lid, turn the heat as low as possible, and let the rice cook undisturbed for 15 minutes. Remove from the heat and allow to cool thoroughly.

Heat a wok or large skillet, then add 2 tablespoons of the oil and the salt. Add the beef and stir-fry for 4 minutes, stirring well to break up any clumps of meat. Remove the cooked meat from the wok and set aside. Drain the oil from the wok. Reheat the wok and add the remaining 2 tablespoons of oil. Then add the garlic, ginger, chili bean paste, and curry powder and stir-fry for 30 seconds. Now add the cooked rice, beef, and green onions and continue to stir-fry another 5 minutes. Serve at once, or allow to cool and serve at room temperature.

Bean Sauce Noodles

This northern Chinese original is one of the quickest and easiest meals you can make: cooking the noodles accounts for most of the time involved, and once they are covered with boiling water you can leave them. While waiting, you could put together a nice salad and slice some fruit for dessert. Instead of pork and rice stick noodles, you could use ground beef and egg noodles to make this dish.

Shopping List
3/4 pound ground pork
Green onions

Preparation Time: 23 minutes Cooking Time: 6 minutes

Serves: 4 to 6

R E C I P E

Bring a large saucepan of water to a boil, remove it from the heat, and add the rice noodles. Let stand for about 15 minutes. While the noodles are soaking, prepare the rest of the ingredients.

Drain the noodles and toss them with the soy sauce and toasted sesame oil. Heat a wok or large skillet and add the peanut oil and pork. Stir-fry for 2 minutes, breaking up any clumps of meat. Then add the bean sauce and sugar and cook for 3 minutes more. Stir in the green onions.

Place the noodles on a platter, ladle the sauce over them, and serve.

½ pound dried rice stick noodles
l tablespoon light soy sauce
2 teaspoons toasted sesame oil
l tablespoon peanut oil
¾ pound ground pork
tablespoons yellow bean sauce
teaspoons sugar
coarsely chopped green onions

Rice & Noodles 129

Rice Noodles with Broccoli

Shopping List
1 pound broccoli
Garlic
Green onions

Preparation Time: 15 minutes Cooking Time: 8 minutes Serves: 4 to 6

I pound broccoli ¾ pound thin dried rice stick noodles

1½ tablespoons peanut oil

2 tablespoons coarsely chopped garlic2 tablespoons coarsely chopped

green onions
3 tablespoons water

2 tablespoons oyster sauce

I tablespoon dark soy sauce

2 teaspoons toasted sesame oil

This recipe takes advantage of the quick-cooking characteristics of rice noodles. Boiled for about 2 minutes, then combined with the blanched broccoli for another few minutes, the noodles make a delectable vegetarian dish for 1 or 2 people. For a more spicy flavor add 2 teaspoons chili bean paste when you add the other sauces. Any leftovers can be reheated very easily by stir-frying.

R E C I P E

Bring a large pot of salted water to a boil. Separate the broccoli into small florets, and peel and slice the stems. Blanch the broccoli pieces in the boiling water for 4 minutes.

Place the rice noodles in a large heatproof bowl. Drain the hot water from the blanched broccoli over the rice noodles and immerse the broccoli pieces in cold water. Drain the broccoli thoroughly and set aside.

Let the noodles stand in the hot water for 2 minutes, then drain. Heat a wok or large skillet, then add the oil, garlic, and green onions. Stir-fry for 20 seconds. Stir in the drained rice noodles and broccoli and continue to stir-fry for 1 minute. Add the water, oyster sauce, dark soy sauce, and toasted sesame oil and cook for 2 minutes. Turn the mixture onto a platter and serve at once.

Spicy Rice Noodles with Mussels

This dish is useful for entertaining a large group of friends at short notice. Only the careful cleaning of the mussels takes any time; the rest of the preparation is very quick. Make sure that all the mussels are firmly closed before cooking: throw away any that do not close up when touched or that have damaged shells. You can substitute prawns or clams for mussels, but any seafood you use will result in a tasty and substantial dish that, with rice noodles, for example, makes a complete and satisfying meal.

Shopping List 2 pounds fresh mussels Garlic Green onions

Preparation Time: 23 minutes Cooking Time: 8 to 9 minutes, plus 15 minutes' standing time Serves: 4 to 6

R E C I P E

Bring a large saucepan of water to a boil, remove from the heat, and add the rice noodles. Let stand for about 15 minutes, then drain well.

Heat a wok or large skillet, then add the oil, black beans, garlic, and green onions. Stir-fry for 20 seconds and add the mussels, rice wine, bean sauce, and chili bean paste. Continue to cook for 5 minutes, or until all the mussels have opened. Discard any that have not opened. Add the rice noodles and cook for another 2 minutes, mixing well. Give the mixture a final stir and serve at once.

- ½ pound dried rice stick noodles (vermicelli), or rice sticks
- 2 tablespoons peanut oil
- I tablespoon salted black beans, left whole
- 2 tablespoons coarsely chopped garlic
- 2 tablespoons coarsely chopped green onions
- 2 pounds fresh mussels, scrubbed and debearded
- I tablespoon rice wine or dry sherry
- I tablespoon yellow bean sauce
- 2 teaspoons chili bean paste

131

Elizabeth Chong's Noodle Salad

Shopping List
3/4 pound bean sprouts
Green onions

Preparation Time: 15 minutes Cooking Time: 2 minutes

Serves: 4 to 6

1/3 pound dried bean thread noodles
 1 tablespoon peanut oil
 2 teaspoons salt
 3/4 pound bean sprouts
 6 green onions, finely shredded
 1 1/2 teaspoons chili bean paste
 1 1/2 tablespoons white rice vinegar
 1 tablespoon light soy sauce
 2 teaspoons toasted sesame oil

s one of Australia's leading teachers of Chinese cooking, Elizabeth Chong is very much worth listening to. And, because she leads so busy a professional life—teaching, traveling, demonstrating, and writing—she is an authority on quick, easy, and delicious meals. This recipe, which I have adapted from one of her own, represents the best of good food, even though it is so simple to prepare. Serve the salad on a bed of lettuce surrounded with sliced tomatoes as an unusual side dish—most refreshing on a warm day!

R E C I P E

Soak the noodles in a large bowl of warm water for 5 minutes. When the noodles are soft, drain them well and cut them into 3-inch lengths using scissors or a knife.

Heat a wok or large skillet, then add the peanut oil, salt, bean sprouts, and green onions. Stir-fry for 10 seconds, then add the chili bean paste, white rice vinegar, soy sauce, toasted sesame oil, and noodles and cook for 1 minute. Allow the mixture to cool, then refrigerate. Serve cold as an accompaniment to grilled or cold meats.

Ground Pork, Peas, and Rice Casserole

This is a typical Chinese dish, designed to comfort, to satisfy, and to relax the body and soul. It reheats very well (when it is perhaps even tastier), and is a meal in itself. Serve it with a favorite salad, and you will have a splendid, complete meal.

Shopping List
1 pound ground pork
1/2 pound fresh peas, shelled, or
1/4 cup frozen peas
Green onions

Preparation Time: 15 minutes Cooking Time: 25 minutes Serves: 4

R E C I P E

Put the rice in a large, heavy saucepan with the water and bring it to a boil. Continue boiling for about 10 minutes, or until most of the surface liquid has evaporated. The surface of the rice should have small indentations and look rather like a pitted crater. At this point, cover the pan with a very tight-fitting lid and turn the heat as low as possible.

While the rice is cooking, prepare the rest of the dish. If you are using fresh peas, blanch them in boiling water for 2 minutes, drain, and set aside. If using frozen peas, let them thaw at room temperature.

Heat a wok or large skillet, then add the oil. Add the pork and stir-fry for I minute, then add the peas, soy sauces, oyster sauce, and rice wine. Continue to cook for another 2 minutes, then add the green onions. Place this cooked mixture on the top of the rice, cover, and continue to cook over the lowest possible heat for another 15 minutes (the rice should cook for a total of 25 minutes). Serve at once. Drizzle additional oyster sauce over the top of the casserole if you wish.

2 cups long-grain rice
3 cups water
½ pound fresh peas, shelled, or
¼ cup frozen peas
1½ tablespoons peanut oil
1 pound ground pork
1 tablespoon light soy sauce
1 tablespoon dark soy sauce
1 tablespoon oyster sauce
1 tablespoon rice wine or
dry sherry
3 tablespoons finely chopped
green onions

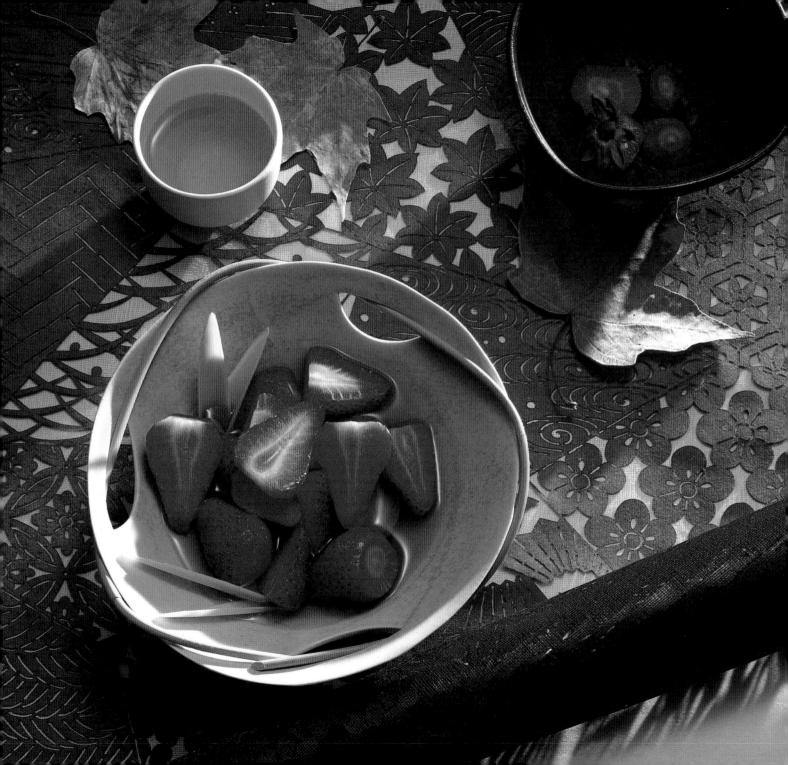

Strawberries with Orange Liqueur Page 141

esserts are not the forte of Chinese cuisine; indeed, they are the one weak element in all of that venerable cooking. Why this is so is a complex question. That it is so is undeniable, so in this section I have kept to quick and easy Western themes but with a Chinese accent manifest in the emphasis on fruit. All the recipes are extremely easy to prepare and deliciously refreshing. The use of fruit is appropriate because of its ease of preparation, its versatility, and its cleansing lightness after the more intense Chinese flavorings.

- I. Mango Fool
- 2. Lichees with Papaya Sauce
- 3. Papaya and Grapefruit Delight
- 4. Strawberry or Raspberry Fool
- 5. Strawberries with Orange Liqueur

Mango Fool

Shopping List1 pound fresh mangoes
1 cup heavy cream

Preparation Time: 20 minutes

Cooking Time: None

Serves: 4

I pound fresh mangoes 2 tablespoons sugar I cup heavy cream This rich but refreshing dessert brings a meal to a close with a Southeast Asian touch. Fresh ripe mangoes are irresistible.

R E C I P E

Peel and slice the mangoes, discarding the seeds. Puree the fruit in a blender or food processor. Put the puree through a fine sieve and stir in the sugar. Whip the cream until it forms stiff peaks. Gently fold this mixture into the mango puree. This dish will keep for 3 to 4 hours covered with plastic wrap in the refrigerator.

Lichees with Papaya Sauce

Lichees are a sweet exotic fruit that is more and more available in the West. Try to use fresh ones with this dramatic sauce for an elegant dessert fit for any occasion. The sauce can be prepared several hours in advance and refrigerated, tightly covered with plastic wrap until you need it.

Shopping List 1 pound fresh or canned lichees 1 large papaya, about 1 pound

Preparation Time: 15 minutes **Cooking Time:** None

Serves: 4 to 6

R E C I P E

Slice the papaya in half lengthwise and remove the seeds. Peel the outside skin and cut the flesh into slices. Puree the slices in a blender or food processor and stir in the sugar. If you are using fresh lichees, peel and pit them. If you are using canned lichees, drain them well.

To serve, put some papaya sauce on each plate and top with the lichees.

I large papaya, about I pound 2 tablespoons sugar I pound fresh or canned lichees

Desserts 137

Shopping List

1½ pounds papaya 2 grapefruit 1 lemon

Preparation Time: 15 minutes

Cooking Time: None

Serves: 4

rapefruit is sometimes taken for granted, its tartness and sweetness overlooked in this age of more glamorous fare. But it takes on new dimensions when paired with papaya, and the result is a refreshing dessert dish. For more color and elegance, add fresh strawberries or raspberries.

1½ pounds papaya 2 grapefruit

2 tablespoons fresh lemon juice

2 tablespoons sugar

R E C I P E

Slice the papayas in half lengthwise and remove the seeds. Peel the outside skin and cut the flesh into slices. Peel the grapefruit and divide the flesh into segments. Arrange the fruits on a platter and sprinkle with the lemon juice and sugar. Wrap the platter tightly with plastic wrap until you are ready to serve.

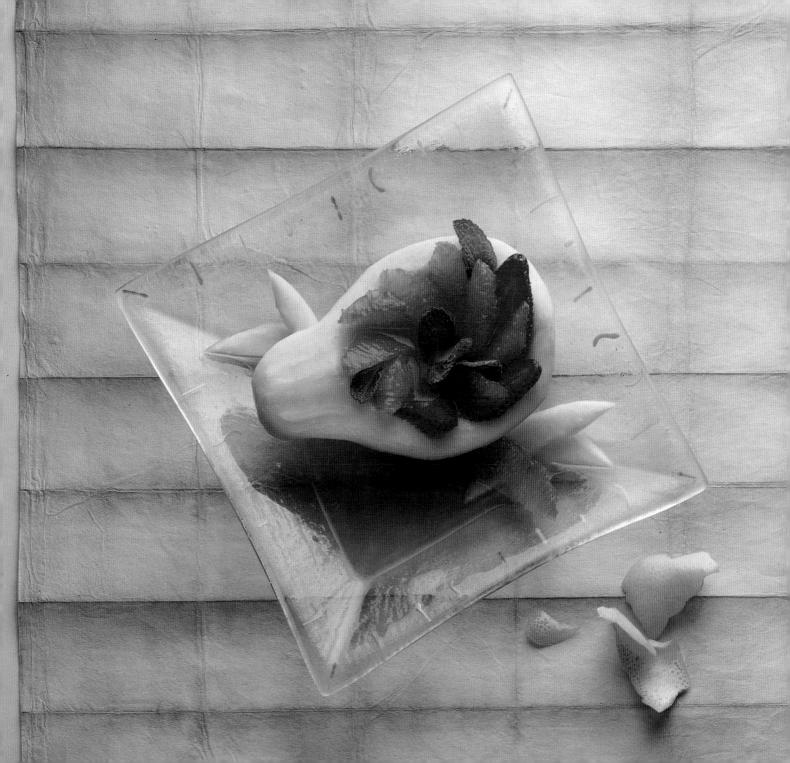

Strawberry or Raspberry Fool

Shopping List

1½ pints fresh strawberries or raspberries1 cup heavy cream

Preparation Time: 8 minutes **Cooking Time:** None

Serves: 4

I ½ pints fresh strawberries or raspberries2 tablespoons sugarI cup heavy cream

When fresh berries are in season, make the most of them. Try this refreshing dessert; it is quick, easy, and elegant.

R E C I P E

Hull and wash the strawberries. Puree the berries in a blender or food processor. Stir in the sugar. Whip the cream until it forms stiff peaks, then gently fold it into the berry puree. This dish will keep for 3 to 4 hours covered with plastic wrap in the refrigerator.

Strawberries with Orange Liqueur

This is a lovely coda to any meal, elegant and very easy to prepare. It can be made hours in advance. Serve it perhaps with some plain cookies or cream, as part of a meal for family or friends.

Shopping List1 pint fresh strawberries Orange liqueur

Preparation Time: 8 minutes, plus 2 hours of marinating Cooking Time: None Serves: 2

R E C I P E

Clean and hull the strawberries. Toss them gently in a bowl with the sugar and orange liqueur. Cover with plastic wrap and refrigerate for at least 2 hours before serving.

I pint fresh strawberries 3 tablespoons sugar I tablespoon orange liqueur

Quick and Easy Menus

COOK AHEAD AND SERVE LATER

Do-Ahead Reheatable Lamb Stew, or Do-Ahead Reheatable Black Bean Spareribs Elizabeth Chong's Noodle Salad

SIMPLE FAMILY MEAL

Ground Turkey Patties Bean Sauce Noodles Your favorite salad Mango Fool

SUNDAY FAMILY DINNER

Chinese Barbecued Chicken Potatoes in Curry-Coconut Sauce Your favorite salad Fresh fruit

TOO BUSY TO COOK

Fast Seafood Soup Your favorite salad Bread

MENU ON THE RUN

Ground Pork, Peas, and Rice Casserole

SUNDAY NIGHT SUPPER

Fast Spicy Meat Sauce and Rice Noodles Tossed green salad Papaya and Grapefruit Delight

MIDWEEK BLUES MENU

Tri-Color Soup Stir-fried Pork with Lichees Steamed rice

MENU FROM THE LARDER

Crispy Chicken in Garlic-Ginger Sauce Stir-fried Peas with Cilantro, Green Onions, and Sesame Oil Steamed rice

FAST LUNCHEON

Quick Orange-Lemon Chicken Steamed rice Your favorite salad Fresh fruit

ONE-DISH MENUS FOR A CROWD

Hot and Spicy Rice with Beef, or Spicy Rice Noodles with Mussels, or Fast Curried Fish Stew Steamed rice

RAINY DAY DINNER

Baked Curried Chicken Thighs Steamed rice Fresh fruit

DRINKS AND NIBBLES

Spicy Fried Cashew Nuts Crispy Prawns

A PRE-THEATRE DINNER

Five-Minute Fish Cooked on a Plate Bright Pepper and Green Bean Stir-fry Your favorite salad Fresh fruit

ROMANTIC DINNER

Chicken and Watercress Soup Steamed Salmon with Black Bean Sauce Potatoes with Cilantro, Green Onions, and Sesame Oil Dressing Strawberries with Orange Liqueur

QUICK AND EASY ENTERTAINING

Tomato-Ginger Soup Ten-Minute Poached Salmon with Green Onion Sauce Oyster Sauce Asparagus Fresh fruit and cheese

LIGHT SUPPER FOR AFTER-THEATRE

Grilled Prawns with Cilantro and Ginger Sauce Cold Cucumber Salad Quick Chinese Chicken Salad Strawberry Fool

AN ELEGANT MENU FOR AN UNEXPECTED GUEST

Fast Curried Fish Stew, or Fifteen-Minute Steak Green Rice Your favorite salad Mango Fool

Index

Baked Curried Chicken Thighs 72 Barbecued Chinese Spareribs 97	Five-Minute Fish Cooked on a Plate 56 Fried Fish with Whole Garlic 61
Bean Sauce Noodles 129	G
Beef with Ginger and Pineapple 84	Green Rice 127
Braised Chicken and Mushroom Casserole 73	Grilled Lamb Chops with
Bright Pepper and Green Bean Stir-fry 111	Chinese Marinade 100
	Grilled Prawns with Cilantro and
С	Ginger Sauce 31
Chicken with Rice Noodles in Soup 39	Ground Pork, Peas, and Rice Casserole 133
Chicken Thigh Casserole with Orange 75	Ground Turkey Patties 80
Chicken and Watercress Soup 37	<i>525 mm</i> 2 mm 5
Chinese Barbecued Chicken 78	н
Chinese Barbecued Chicken Wings 28	Hot Pepper Prawns 53
Chinese Lamb Curry 98	Hot and Spicy Rice with Beef 128
Chinese-style Omelette 120	Hot and Spicy Stir-fried Cabbage 107
Cold Cucumber Salad 27	Hot and Tangy Ground Lamb 99
Crispy Chicken in Garlic-Ginger Sauce 70	Hot and Tangy Zucchini 121
Crispy Prawns 32	2.207
Custard with Ground Pork, Green Onions,	L
and Oyster Sauce 95	Lichees with Papaya Sauce 137
,	1 ,
D	M
Do-ahead Reheatable Black Bean Spareribs 96	Mango Beef 86
Do-ahead Reheatable Lamb Stew 101	Mango Fool 136
	Marinated Broiled Pork Chops 94
E	Minced Prawns with Lettuce Leaves 29
Elizabeth Chong's Noodle Salad 132	Mussels in Black Bean Sauce 54
8	
F	0
Fast Curried Fish Stew 55	Oyster Sauce Asparagus 104
Fast Seafood Soup 43	Oyster Sauce Bean Curd 106
Fast Snow Peas with Mushrooms 115	•
Fast Spicy Meat Sauce for Noodles 88	
Fifteen-Minute Steak 89	

P

Papaya and Grapefruit Delight 138 Potatoes with Cilantro, Green Onion, and Sesame Oil Dressing 114 Potatoes in Curry-Coconut Sauce 117 Prawns in Ginger Sauce 51

Q

Quick Bean Curd in Spicy Chili Sauce 105 Quick Chinese Chicken Salad 66 Quick and Easy Chicken Stock 36 Quick Fried Rice 124 Quick Orange-Lemon Chicken 68 Quick Pan-fried Spicy Fish 57

R

Red-cooked Chicken Wings 74
Red-cooked Winter Vegetables 118
Rice with Chinese Sausages 125
Rice Noodles with Broccoli 130
Rice Wine-steeped Fish 62
Rich Beef Soup 44

S

Spicy Fried Cashew Nuts 26
Spicy Hot Chicken with Basil 71
Spicy Rice Noodles with Mussels 131
Spicy Szechwan-style Beef 87
Steamed Salmon with Black Bean Sauce 59
Sterling's Stir-fried Chicken with Kiwi 69
Stir-fried Beef with Onions and Mint 90
Stir-fried Chicken Livers with Onions 79
Stir-fried Eggs and Corn with Green Onions and Ginger 108

Stir-fried Fava Beans with Ham and Green Onions 112 Stir-fried Fennel with Garlic 109 Stir-fried Ginger Spinach 116 Stir-fried Peas with Cilantro, Green Onions. and Sesame Oil 113 Stir-fried Peppers with Scallops 48 Stir-fried Pork with Lichees 93 Stir-fried Pork with Pineapple 92 Stir-fried Prawns and Peas 50 Stir-fried Scallops with Leeks 49 Stir-fried Smoked Chicken with Napa Cabbage 76 Stir-fried Turkey with Peppers 81 Strawberries with Orange Liqueur 141 Strawberry or Raspberry Fool 140

Т

Ten-Minute Poached Salmon with Green Onion Sauce 60 Tomato Beef with Onions 85 Tomato-Ginger Soup 40 Tri-Color Soup 41

W

Whole Fish Soup 42 Whole Prawns Baked in Salt 52

For information on how you can have *Better Homes and Gardens* delivered to your door, write to Mr. Robert Austin, P.O. Box 4536, Des Moines, IA 50336.

NOTES